Edi Mils

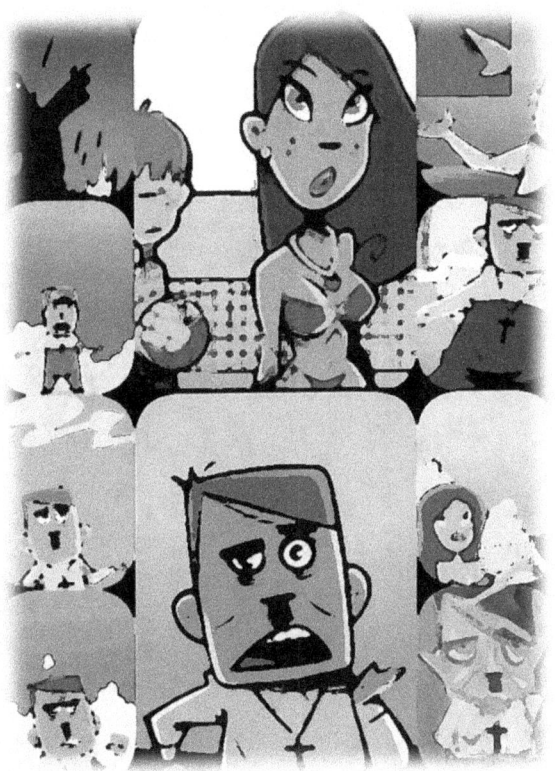

STIGMATLER

A Movie Script

in collaboration with:

STIGMATLER

This is the unusual and grotesque tale about Jesus Christ who comes back on Earth, but in Adolf Hitler's clothing (except two little stigmata on his wrists that make him recognize as the Messiah) for God's will: he has to challenge the world about the capability to recognize the Righteous in Evil's appearance. All this will starts up a series of satirical misunderstandings that'll end in a new sacrifice...

EDI MILS

Stefano Edilio Milsani Bedetti, aka EDI MILS, has got a degree in Movie History at Turin (IT) University. Since 2002 till today he has realized some short movies and documentaries as screenwriter and filmmaker. In 2012 he moved to Rome and cooperates with different production companies.

http://vimeo.com/nullares

https://nullares.tumblr.com/

http://www.imdb.com/name/nm3865789/

Edi Mils

"STIGMATLER"

The scene is in the beyond, in Heaven. A man, who is Jesus Christ, at least as we are used to depicting him in our traditional iconography, moves in a blue-grey indefinite landscape. He stops and next to him appears the image of a burning bush, and near the bush there's a sort of red cloud. Then a voice comes out of the burning bush to him, the Christ, while the red-throbbing cloud continues to stand still and crackling at the same time, as if to watch that scene. The bush presents itself as God the Almighty Father, and has called his son to inform him that the time has come for his second coming to Earth, which had been repeatedly proclaimed by the Gospel and the prophets.

The time is now ripe, after over 2,000 years humankind is destined to make a second great evolutionary leap that will be realized only after a long time. Jesus therefore wants to know what the Father has in store for him: he's immediately satisfied. He will have to return to Earth, but this time no longer in the guise of a carpenter's poor son, but assuming a look completely similar to Adolf Hitler, also in the dressing style. Jesus is stunned, and asks the Father why he made such a decision. God explains to him that he wants to challenge Humanity on the theme of forgiveness and evil, teaching men to try to be always good even with their worst enemy.

To love not only the last ones (this was in fact the message of Christ's first coming to Earth), but also and above all the evil ones, accepting them for what they are. In short, Christ will return to the world in the guise of the one who in some ways was considered the emblem of the Incarnate Antichrist. The only sign that God gives him to recognize as the Savior are two real little stigmata in the shape of a cross on the palms of both hands; two stigmata that are perpetually bleeding but that will never cause his death (hence the name of Stigmatler, that is Hitler with stigmata).

And Jesus must know how to convince men, in this unusual look, that he is not the Devil but the Son of God, returned to life by the will of the Father, and herald of new teachings, which will further complete those of the New Testament. Although reluctant, Christ goes back to the will of God the Father, and also of the Holy Spirit (represented by the red cloud floating at the side of the bush). Thus, in a flash, the only-begotten the Son finds himself catapulted into a remote corner of the planet. He is identical to Hitler, with his Nazi uniform, mustache, swastika and boots, and no one could ever distinguish him from the Führer. He is now in the middle of the vast ocean and is walking on the water.

After several miles of water, he finds himself on a beach, miraculously dry. Well, on this beach the body of a young woman who drowned off the coast has been recovered. Some people are around her, waiting for help and an ambulance to arrive. All of them look astonished at Stigmatler because of his resemblance to the Führer: they believe that's only a joke, even if we are in the middle of summer and not at Carnival. However Stigmatler does not care about the murmurs of the watchers, he approaches the young woman, and speaking to her as he spoke to Lazarus. The girl is resurrecting.

Those who watch the scene are stunned: a man identical to the worst criminal in history who speaks like a prophet is doing miracles. Without giving any explanation, Stigmatler leaves: the arrival of an ambulance is now completely useless. Some boys and girls, witnesses of the scene, see Stigmatler returning to the Ocean and walking on it as if nothing had happened; they try to call him, but he does not answer. Then a girl takes her smart-phone cam and starts filming it and then posting it on the social application curiously called Trojagram. As Stigmatler disappears into the distant ocean horizon, reactions on the web begin to multiply, and everyone

believes it is a special effect put there by someone in the mood for jokes: a man identical to Hitler who walks on the water like Jesus. In a short time the video becomes viral: from Trojagram to Lothargram to the varied Mufflebook and Pisstweer, all the main social networks in the world are invaded by Stigmatler's video and by the reactions of several users. One of the first people to catch him is the very seductive journalist Vicky, presenter of a scandalous TV program that is losing audience and consequently also the sponsor's funds. Vicky sees in this situation a possible scoop and, having informed her boss, she immediately starts going around with a cameraman

looking for Stigmatler, in order to interview him and understand who he really is. Meanwhile, Stigmatler, waiting for the will of the Father, that is always somehow obscure before the concrete facts happen in reality; so Stigmatler is now catapulted into the heart of some unknown contemporary European city, where unfortunately is taking place a gathering of nazi-skins and skin-heads. They immediately notice the presence of this bizarre person, identical to their idol: the dismay is remarkable. They try to question him, but Stigmatler doesn't answer. They want to know who he is and why he looks so much like the Führer. Since they don't get satisfaction,

they decide to beat him; but the Stigmatler doesn't defend himself at all, and at the end he emerges completely unscathed from the fight. He tries to explain to them that he is the Christ, returned to Earth by the will of the Father to convert humanity and teach it to love even its worst enemies, but of course no one believes him. So Stigmatler shows them his bleeding stigmata, as a sign of his authenticity: but he gets the opposite effect, or better the Nazis begin to believe that he is the reincarnation of Hitler, returned to Earth to lead them to the Third World War and the conquest of the planet.

They begin to exult, waving flags and calling the attention of all passers-by: Stigmatler then calls for divine help to get out of that situation. So he suddenly disappears among the exulting neo-Nazis. In the meantime the web news about Stigmatler's deeds have reached the Press, and in the Church-Ecclesial circles someone starts to discuss the mysterious video that appeared on the web, in which Stigmatler walks on the water. That event witnesses are interviewed on TV and tell of how Stigmatler resurrected a dead drowned girl on the beach. In the Vatican State there's an official meeting in the presence of some of the highest prelates, to decide how to deal with this "phenomenon".

Some dismiss the matter as a joke by this weird one in search of publicity, but others seem to take this fact very seriously. In the end it is decided to wait for future developments to see the guy's next actions. In the meantime, Stigmatler, who had moved away from the Nazis (who were electing him as their new leader), now finds himself catapulted into a very poor country in some part of the Third World, and moreover destroyed by an earthquake. Stigmatler moves through the rubble and notices the presence of desperate people. Even the desperate people notice him, stunned: someone would like to attack him because of his dictatorship costume.

Photographed by a tourist, Stigmatler promises the villagers to re-build their destroyed village in just three days, getting everything back to normal life. Welcomed by whistles and mockery, he does not give up, and after three days, miraculously, the country now appears completely modernized and rebuilt. But no one understands how Stigmatler did it. So many begin to acclaim him as a sort of Messiah; some call the mayor and the rabbi of the village to meet him, but Stigmatler has already disappeared. Meanwhile, another TV female presenter, Tonia, has decided to chase Stigmatler and compete with Vicky.

Tonia, who had attracted a little attention to herself thanks to a case of fake harassment of which she had accused her former boss, then unjustly fired, obtained permission from her new superiors to search for Stigmatler and try to bring it directly to the TV transmission, live. Meanwhile Vicky, the other journalist and influencer and Tonia's competitor, went to the beach where Stigmatler appeared for the first time, interviewed a lot of people, but nobody knows where and how that strange guy ended up and if he'll ever come back. Not knowing which fish to catch, Vicky decides to wait for the next events: and in the meantime, the news of the miracle performed

by Stigmatler among the earthquake victims has already spread. Stigmatler is sent now in the middle of the desert; and he rightly suspects that God the Father intends to put him to the test again, as he did more than 2000 years ago, when Christ found himself wandering for 40 nights and 40 days in the desert. In fact, a guy totally similar to Jesus appears in front of him. The two have an argument, both claim to be the son of God. But then Stigmatler discovers the cards: the fake Jesus is actually Satan, who assumed the fake clothes of an angel of light (what often happens in real life). Stigmatler thus throws the Evil One back into the depths of hell, although the Devil

warns him that he will return later to undermine his path. In the remaining days, wandering in the desert, Stigmatler perceived his own isolation and solitude in a very profound way; so he decided to enlist the new twelve apostles. He asked the Father to take him somewhere on planet Earth where he could make proselytes, and immediately found himself catapulted into the park of a luxury mansion in Sicily. Everything is shiny and perfect, and after a few moments Stigmatler realizes that he has been sent to a mansion of the bosses of Cosa Nostra. At first he is frightened, then notices a small group of "godfathers" having a meeting.

Some of them are already thinking of killing him, when the beautiful girlfriend of one of them appears, claiming to have seen this guy on the social networks, and on Trojagram in particular, and to have seen his videos: he was walking on the water and reconstructing a town devastated by an earthquake as it was a joke. The girl defends Stigmatler from the onslaught of the mafia and even offers herself to him, dreaming for a long time of being able to go to bed with a famous man. But Stigmatler resolutely rejects her, and exhorts the Holy Spirit to help him convert the violent mafia gangsters and transform them into his disciples.

In a short time, these men stop their lewd expressions and swarf, and completely change their moods. Then Stigmatler explains to them that he is the Christ who returned to Earth to teach human beings to evolve and to love even the most absolute Evil (of which he has taken on the appearance), forgiving him. To give the new apostles (former Mafia leaders) a demonstration of his divinity, he shows them the stigmata in the shape of a cross that bleed perpetually on the palms of both his hands. Unbelieving, the 12 apostles decided to follow him wherever he went. Stigmatler then orders that they have to go to help the poor migrants who will land

on the shores of the Mediterranean, but some of the apostles protest: they are in fact against the policy of the government, which pretends to help illegal immigrants with facade initiatives only to clear its conscience in front of the electorate (in addition to obtaining, this way, a new potential electorate, that one exactly of the migrants). But Stigmatler is unshakable, and he wants to go to the coast, precisely with the aim of unmasking the pharisaic American/European policy of aid to the weakest. While Vicky, the journalist, completely on the other side of the world, is waiting in vain with her cameraman for the return of Stigmatler to the coasts

from which he had come, here comes an unexpected phone call from her editor-in-chief, who orders her to go immediately to the shores of the Mediterranean to film the arrival of new migrants in terrible conditions. She is stirred by this fact - losing what may be the scoop of her life, that is filming the Führer walking on the water; Vicky is forced unwillingly to leave that beach and land in Italy; she still does not know she will have the opportunity to finally see Stigmatler in action right there. Meanwhile, in a corner of the coast of the Mediterranean Sea, here come boats of desperate migrants, mixed with disguised boatmen.

Stigmatler and the 12 disciples (renamed respectively with names of famous former Nazi leaders: Himmler, Goebbels, Göring, Hess, Bormann, Rosenberg, Ribbentrop, Speer, Eichmann, Heydrich, Röhm, Schreck) came walking on the waters right on the beach concerned. The migrants and those who help them to land are watching Stigmatler completely astounded. Some of them have already watched the videos and read the articles on the web and on the Press. Stigmatler proclaims that he has come in peace, and to show them his good faith ordering to some of the disciples to go to sea and catch a fish; to other ones to go to one of the rescuers and get a piece of bread given to him.

After that the Jesus-Hitler multiplied bread and fish in front of everyone. The migrants, hungry and unhappy, immediately jump on the copious quantities of food. Many throw themselves at Stigmatler's feet and adore him as if he were a God. Some people ask Stigmatler to help them find a good place to live in their new homeland; then Stigmatler with another miracle makes a gigantic platform arriving from Heaven on which there is an ethereal marvelous city. Meanwhile Vicky has arrived with her Tv crew and is attending the event; she immediately orders her cameramen to film, but strangely the cameras can't capture anything of

what's happening – the miracle of the heavenly City for immigrants. The huge crowd of poor people climbs up an ethereal ladder that leads to the ethereal city, all with their families and children, and settle down with their gifts in sumptuous palaces. A city made with an architecture never seen before, which does not seem to be of this world. Vicky and all the other witnesses now watch astonished the scene, but at the same time Vicky is furious because she wanted to broadcast the live television of the event, but the cameras at that time did not work. The gigantic ethereal city with all the migrants inside continues to float wonderfully in the sky,

without actually moving a millimeter, like a large balloon suspended in mid-air, but that continues to stay over the Sicily without leaving, and without casting any shadow on the ground. Vicky runs to Stigmatler and wants to interview him, but he refuses and disappears. In the meantime, the other reporter, Tonia, Vicky's rival, has arrived on the scene, but it is now too late. Tonia first tries to bribe Vicky's cameramen to get the exclusivity of the images shot, but he is explained her that it was not possible to film anything that happened. The rescuers and the smugglers in the meantime have disappeared terrified; there is no longer anybody to interview.

Then a beautiful man, a smuggler (actually he's the Devil again in fake clothes as not to be recognized) approaches the two reporters and tells them that he has the secret to meet and catch Stigmatler. "Very well", they say Vicky and Tonia, "what should we do?" The beautiful smuggler says he answers to the name of Ilvastor, and wants a huge cash ransom to deliver them Stigmatler. They can make a single live broadcast in a single TV broadcast, a world premiere. Vicky and Tonia, extremely greedy, don't want to make half the cake at first. Ilvastor looks at them mischievously. Shortly afterwards, the three of them find themselves in a luxury hotel where they are making an orgy.

The deal is combined, the two women will find a way to get the huge amount of money from their respective financiers and Ilvastor will deliver Stigmatler to them for a big TV event and streaming, where the two women will interview the miraculous Fuhrer, and maybe even convince him to do a miracle in real time. Meanwhile in ecclesial circles and in the Vatican there is increasing concern about the Stigmatler phenomenon, the news of which is now rapidly spreading to all corners of the planet. The mysterious celestial migrant city continues to float over Europe, the many migrants live there happily and prosperously without asking anything of anyone.

The flying city then arrives above the Vatican. Some papal messengers and high prelates watch the whole scene stunned. The ethereal staircase extends downwards to St. Peter's Square and an Indian descends from it. The Indian warns the bishops that Stigmatler is neither a clown nor an incarnation of the Evil, but the anointed Lord returned to Earth in fake Nazi clothes for God's will. He also warns the prelates that a deception is being done against Stigmatler to humiliate him before the whole world and annihilate him. This deception was desired by the Evil Forces from the beyond. Then the Indian disappears and goes back to where he came from.

The prelates, bishops and cardinals, are stunned and don't know how to comment on what happened. In the meantime Vicky and Tonia are organizing themselves more quickly to prepare the mega world premiere Tv event. The two female journalists have forgotten their old bitter rivalries to unite in a common effort to create the biggest (and most cynical) scoop of their mediatic (and carnal) existence. In the meantime Stigmatler and his 12 apostles continue their saving deeds all over the planet. Stigmatler then goes to a hospital in the dying ward and miraculously heals several sick people, only with the imposition of his hands with

bleeding stigmata, almost like a prano-therapist; those who could no longer walk, now walk; and those who had cancer are suddenly healed; those who were deformed have recovered a healthy appearance, and those who were disabled have surprisingly lost their disability. Then Stigmatler and his men break into a party of rich people mixed with high prelates and politicians, there are also many beautiful women, and Stigmatler and his men overturn all the banquets containing the buffet and drinks for appetizers, ruin the decorations of the salon and scare a good part of the guests. Stigmatler swears at the hypocrisy of part of the world of Church and

politics, which seem to venerate only power and money - an existential condition that fights the essence of religious life as well as spirituality. The most surprising thing for all, however, is that these words and speeches come from a man who looks identical to Adolf Hitler, both in his physical appearance and in his way of dressing. After the riot acts during the feast some of the politicians thus give orders to immediately arrest Stigmatler. The disciples, revealing themselves in all their human frailty and weakness, run away with their legs up. Among those who arrest Stigmatler, or rather, right at the head of the clique, there is Ilvastor, the

smuggler (Devil) who had promised the two television reporters to hand him over for a live interview. The result of all this, however, is that in the meantime, the poor Stigmatler is locked up in a maximum security prison. In proclaiming his innocence and his true divine origin as a Messiah returned to Earth, Stigmatler shows the policemen and prelates the sign of his stigmata, perpetually and inexplicably bleeding, on his hands; but these do not want to believe him and tell that he has procured those wounds himself as a special effect or a Carnival trick. Stigmatler is thrown into prison, in a severe isolation.

The apostles have instead taken refuge in an abandoned bunker in Germany and are deciding what to do. Some of them would like to join Stigmatler in prison and help him get out. Others, however, decide to stay in the bunker to pray and wait for the Almighty Father to do his will: they don't know if, however, his will is to sacrifice his only-begotten son again, or to free him to continue his mission of preaching and converting people. In the end, too many roosters in a henhouse thinking with different heads. One of the apostles was determined to lead a revolt to go and free Stigmatler from prison, but the others were not sure enough, so

they continued to review the Gospel and the New Testament, more certain of the fact that the Messiah would prefer to go to suffering and death and then rise again, as happened 2000 and years ago. In the prison, while he was sleeping, Stigmatler was awakened by some strange suspicious noises and some steps in the direction of his cell; <u>looking out</u> at the bars, he noticed that the neo-Nazis who had acclaimed him at the beginning of his journey on Earth had arrived, we don't know how, and had come here to free him. Stigmatler is not agree with them, but the skinheads have all the equipment to cut the bars and take him away.

To quell Stigmatler's opposition to their design, they first stun him with a metal stick and then load him on the shoulders and drag him away, devoid of consciousness and senses. Stigmatler is then dragged into a German bunker, or rather a former bunker, not far from the one where his apostles have temporarily gathered, and where the neo-Nazis have their hidden meeting place. They therefore want to proclaim Stigmatler their new leader and be led by him to a general revolt towards the whole world, which restores the foundations of Nazi-fascism on the globe and, if necessary, to do this, leads to fighting a Third World War.

However, in their crazy project against Humankind, the Nazis have not come to terms with Ilvastor, or the Devil, the true anti-Christ, who comes to them in the guise of the usual smuggler, and asks to deliver Stigmatler for a live television, offering the children the sum of 12 million euros in exchange. At this point the Nazis cannot give up. Once the hostage has been handed over, they return to the bunker with the briefcase handed over to them by Ilvastor in their hands, and containing the promised money. But when they open it, under the authentic banknotes, they notice the presence of a very strange sensor, which incinerates all of them and the bunker included.

This explosion, in the middle of the mountains, alerts the apostles, who had taken refuge not far away, and who run away terrified in the nearest country. In the meantime Ilvastor has boarded a personal helicopter with Stigmatler, and leads him to the editorial office of the television studios, where the Tv worldwide Transmission that the whole planet is waiting for, will take place. In the waiting room, before the start of the TV show, Stigmatler and Ilvastor have a very close confrontation, in which Stigmatler understands that he has been kidnapped by the devil for this media conspiracy that ultimately wants to show that he is only an impostor.

So the Antichrist has won another victory, at least apparently, and the Stigmatler will be forced to undergo the interrogations of the two female journalists, that by now have definitively given their souls to the Prince of this world, that is, the Lord of the Underworld. The apostles, hiding in a deserted bar of an unknown village at the foot of the Germanic mountains, and learned from the newspapers the bombshell news that their leader will appear on TV, are in great apprehension, so they decide to tune the TV Broadcast, although some of them would rather go to the studios of TV ... and take Stigmatler away. But in the end they don't have enough courage to do it.

Meanwhile Vicky, Tonia and Ilvastor are ready for that great world premiere event, the Messiah in a Tv studio doing miracles in front of the largest audience, but the two girls aren't conscious their souls are now increasingly chained to their own perversions as well as to the project of Ilvastor (a very good-looking but fake smuggler). Finally it comes the moment of the big live show, an embarrassing mediatic circus more than the most trashy reality show imaginable. Brought in front of the cameras that light up and film him, Stigmatler is placed on a small armchair between the two female journalists, and subjected to a flurry of questions, to which, however, the messiah

always responds only to monosyllables, just as he had done in front of Pontius Pilate, before the crucifixion, before climbing up Mount Golgotha. Vicky and Tonia's facial expressions begin to bleach, even the listening audience machine oscillates, the online streaming visualizations decrease fearfully, in short, the audience seems greatly disappointed with the progress of the Tv program, Stigmatler seems just a jester who looks like Hitler in every way but who is not able to produce any kind of miracle. Despite the repeated requests of the presenters, he categorically refuses to show his divine powers in front of the media audience; he's not a puppet who obeys the lust of the audience of those two evil women on command.

Ilvastor isn't among the studio television audience. Finally, a huge thunderstorm, with hail and lightning, tears through the ceiling and walls of the studio, completely tilting the pleasant Tv broadcasting. The two girls try in vain to save themselves, but immediately one of them, Vicky, ends up roasted by a lightning bolt that strikes her directly in the middle of her thighs; while Tonia, in the vain attempt to escape from her studies, dies recklessly under a blanket of hail that freezes her. Stigmatler changes his appearance into Ilvastor, shortly before disappearing into the depths of Hell; he fooled Vicky and Tonia and everyone, having assumed the fake guise of the Messiah.

Panic broke out in the studio, and the public and technicians are screaming and trying to get away. When the building is now deserted, and none of the viewers or web viewers can see what's happening anymore. The real Stigmatler, run away from prison, has arrived on the stage, and now he makes the real miracle: a gigantic crematorium coming out of the wings of the TV studio. Stigmatler turns one last prayer to the Almighty Father: although it costs him an enormous sacrifice, he has understood what he must do. In the meantime, the 12 apostles have managed to arrive at the site... they're the only ones present, and they witness this incredible scene.

Stigmatler reactivated the crematorium off with the stigmatized palms of his hands, and then he locked himself in it. The protests of the disciples are useless. Stigmatler smiles at them and recommends him to spread his verb throughout the world: the time has come to say goodbye definitively. And humankind for the second time hasn't believe in him, the Messiah. He has returned to teach humanity to love above all its enemies, those who reject us or mistreat us, sealing these relationships with forgiveness. Even the most violent crimes against ourselves must be forgiven, and this first of all because man never consumes himself in the temptation of hatred and

revenge, cornerstones of the clever project of the Devil in diverting humanity from the right path. In any case, after three days he will return to visit his faithful followers to definitively sanction his program of divine love, as well as the supernatural origin of his person. Just as it happened at the time of his very first coming. Then Stigmatler miraculously increased the temperature of the oven until it completely melted itself. Thus a blinding glow invades the interior of the device, and the apostles can do no more than helplessly watch the terrible spectacle.

When the light then fades the interior of that oven is completely empty, and none of the audience, just none of those who had followed so anxiously the events of the divine protagonist, had the satisfaction to attend assist, in real time, at his latest miracle. The disciples leave sad and exhausted, but some of them say to wait around for the coming of the third day: maybe Stigmatler will really come back to show himself to them, as he had predicted before dying. So the apostles return to the disused bunker. As they move away, they witness the fire and sudden burning of the television studio, which is completely incinerated by mysterious flames from under the ground.

Then the days pass. The first day, the second day, then finally comes the third day. And the disciples continue to wait hopefully for the ultra-earthly apparition of their late master. And now, at dawn on the third day, the enormous boulder that partially obstructs the den of the old bunker has been removed, and a dazzling, blinding light comes from outside. Frightened, but also curious, the 12 apostles approach the entrance: out there, on an expanse of rocks and meadows in front of the mountain, appears the figure of a beautiful woman, a woman of inhuman beauty, not even the most beautiful girl on Earth can be compared to this creature. Disciples are more than distorted by such a vision.

But the ethereal girl, surrounded by the divine light, is nothing but Stigmatler, who, having given up the role of the fake Führer, tells them that he has returned one last time on Earth to greet them before returning definitively to the right of the Father, waiting for the end of the world, now approaching, and for the Judgment Day. The Messiah reminds them of his promise of eternal life and again urges them to complete the teachings of the New Testament, becoming witnesses in the world of love not only for the least, but also for the wicked, trying to convert them naturally.

The disciples do not understand each other, they do not know how to fulfill their master's order; but he tells them not to fear, little by little he will show them the way, through the events and circumstances that will guide them in the rest of their earthly journey. Then the master, that is the girl of indescribable beauty, disappears. Not far away, a child with a mobile phone in his hand filmed the whole incredible scene, which this time was strangely captured without any problems by the camera's sensor. The ten-year-old child, on holiday in the mountains with his parents, places the short film on the web and on his social network profiles.

In a short time the comments begin to flake, among which the one most posted by people is the following: "But then he was actually the son of God, returned to Earth at the behest of the Almighty". Global awareness; and who knows, this is not the beginning of a new era for Humankind ...

Edi Mils

STIGMATLER

Screenplay

Contacts:

+39 3669351033

nistwala@gmail.com

SCENE 0 (PROLOGUE). EXTERIOR/DAY. THE BEYOND

The beyond is unknowable, so we only see the screen filled with an indefinable color, halfway between white, grey, blue and yellow (we are in Heaven). A scrolling overlay, or perhaps a voice over, reads the following:

NARRATOR

(*voice over*)

The time is ripe. God decided to send his only son Jesus to Earth for the second time.
Humanity is ready to make a further evolutionary and spiritual leap. But this time Christ will have to return among men identical in all respects to one of the greatest criminals of all time: Adolf Hitler. Human beings must learn to recognize the supreme Good in the guise of Evil. Jesus is not very enthusiastic about this choice, but decides to carry out the will of God the Father anyway. Despite his total resemblance to the Führer, God advices him that he will have two small perpetually bleeding stigmata in the shape of a cross on his wrists, and through those stigmata he will work all the miracles. Hence his new name.

SCENE 1. EXTERIOR/DAY. THE BEYOND

CHRIST appears in front of a red burning bush, around there is an indefinite landscape, with swampy and soft atmospheres, with colors that aren't of this world.

> CHRIST
> (*talking to the Burning Bush*)
> Holy Father. Forgive me if I am sinning.

> BURNING RED BUSH
> It is not possible to sin in Heaven.

> CHRIST
> However, forgive me, Father. But explain to me:
> why? Why do I have to return to Earth, and
> looking like that?

> BURNING RED BUSH
> Son, you will understand this along the course
> of the mission.

CHRIST

But Father, humans won't understand your plan. Again they will take me for a sham, and again they will condemn me. This will happen.

BURNING RED BUSH

Son, you are already reasoning according to the World, and not according to God. You must return to Earth, and in those clothes.

CHRIST

And once I'm there, what will I do?

BURNING RED BUSH

Again you will teach Love. Of course they will mistake you for someone else, probably for the Antichrist, but have faith in my Will. Remember that you are not in the Garden of Gethsemane anymore.

CHRIST

Father, this cup that you offer me is very bitter. Perhaps more than crucifixion.

BURNING RED BUSH

The cross, so hated by the World, is actually the sign of victory over it.

CHRIST

All right Father, your will be done, not mine. Forever and ever. But… there is one more thing.

BURNING RED BUSH

Amen!.

CHRIST

There is one more question. Those who want to follow me, how will they recognize me? What sign will you give them?

BURNING RED BUSH

Look at your wrists, son.

Jesus looks at his wrists and observes them bleeding, as if from the old nail wounds. But they don't make him suffer.

CHRIST

I understand, Father. But may you always be my guide, in every moment of this thorny path. Never abandon me, and always stay by my side.

BURNING RED BUSH

Fathers always give good things to children who ask for them, don't they? Don't be afraid, Son. And now go, and the cross will be with you again.

CHRIST slowly disappears, dissolving into the surrounding heavenly landscape, while the burning bush of red fire blazes violently covering the entire screen.

(Opening credits)

Edi Mils's

STIGMATLER

SCENE 2. EXTERIOR/DAY. IN THE MIDDLE OF THE OCEAN.

A MAN COMPLETELY IDENTICAL TO ADOLF HITLER walks on the ocean water. He is dressed like the Führer: Nazi uniform, boots, swastikas. He walks calmly, and he is a little tired and sweaty.

SCENE 3. EXTERIOR/DAY. A BEACH

A GROUP OF BOYS AND GIRLS AGED 20 TO 30 are playing volleyball on the beach near the ocean. At a certain point they notice the strange figure of STIGMATLER walking on waters and coming towards them. They stop playing completely amazed.

 A BOY

 Hey, look that one!

A GIRL takes out her smartphone that she kept hidden in her swimsuit bottoms and hurries to film the scene. Meanwhile, STIGMATLER has landed on the shore. He is completely dry. BOYS AND GIRLS continue to watch him in silence, while the girl stops recording with the camera on her cell phone. STIGMATLER ignores them completely, and moves on.

 A GIRL
 (*voice off*)
 Have you seen? Who is?

SCENE 4. EXTERIOR/DAY. A CORNER OF THE BEACH

In another corner of the beach A SMALL GROUP OF PEOPLE gathered around the body of A WOMAN who had just been recovered from the sea and brought to the shore. THE RESCUERS tried in vain to bring her back to life, but without success. After trying mouth-to-mouth reanimation, A RESCUER turns towards THE SMALL GROUP OF PEOPLE and looks at them with sad expression.

 RESCUER

 No, guys... Nothing to do.

At that moment STIGMATLER arrives and makes his way through THE SMALL CROWD. Everyone amazed is looking at him. Someone comments sardonically on his arrival.

 A MAN

 (*whispering to HIS NEIGHBOR about STIGMATLER*)

A woman is dead, and this one thinks we're at Carnival.

STIGMATLER

Let me pass, O Brothers, please.

Having opened a small gap in the crowd, STIGMATLER approaches the dead WOMAN and bends over her.

RESCUER

(*to STIGMATLER*)

Who are you? Get out of the way, please.

STIGMATLER ignores him. Around him there is like an invisible aura that people are unable to oppose. Leaning over the WOMAN, STIGMATLER places his wrists at her heart level and presses delicately for a few seconds. Within moments, the WOMAN begins to blink and perks up. The bystanders are stunned.

STIGMATLER

(*with meekness, to THE WOMAN*)

Now get up, and he walks.

The WOMAN slowly rises from the sand and regains consciousness. People are incredulous.

> **WOMAN**
> Forgive me, but... I think I fell asleep. What happens?

> **A GIRL**
> (*commenting the scene*)
> That's impossible!

No one dares to say a word. STIGMATLER, meanwhile, has already disappeared.

> **WOMAN**
> (*to the PEOPLE*)
> Do you want to tell me why you look at me like a Martian?

RESCUER

(*stuttering in disbelief*)

No, it's just... We thought you were... drowned.

WOMAN

Drowned?

RESCUER

Yes… You see, I tried to reanimate you, without success. Your heart was no longer beating, I'm so sure of it. But then that guy arrived…

WOMAN

Who?

A MAN

(*shouting*)

He was here! He was here one moment ago… Where did he go?

Everyone turns and notices that STIGMATLER has
already disappeared, as if he was evaporated.
People are even more baffled.

 RESCUER

He had a Carnival costume. He was identical to
 Adolf Hitler.

SCENE 5. INTERIOR/NIGHT. SMARTPHONE GIRL'S HOME. BEDROOM

The GIRL who filmed the scene of STIGMATLER's arrival on the water is sitting at the PC in her bedroom, and next to her is ANOTHER BOY, one of those volleyball players. They watch STIGMATLER's video on the PC screen that she posted late in the morning on the social application called TROJA-GRAM.

 GIRL

 (*to THE BOY*)

Look... We're already at 12,000 views in just a few hours... And they're starting to comment.

 BOY

Yes, but they write things like "What a carnival", or insults... It's better you remove the video, people think it's a special effect...

GIRL

Maybe, but on Muffle-book they have already opened a group where they discuss another miracle... It seems that he resuscitated a drowned woman just by placing his wrists on her body...

BOY

How disgusting. They are already speculating on it. Keyboard Warriors.

GIRL

You too saw him walking on water, like Jesus Christ!

BOY

Look, today there are tricks that you can't even imagine. Thanks to A.I. … Of course, I don't know how he did it. And he also had the bad taste to show makeup and wear dress like Hitler!

SCENE 6. EXTERIOR/NIGHT. NEAR THE SEA, AMONG THE PALMS.

STIGMATLER relaxes after the walk on the water and the miracle of the drowned woman. Meditatively, he looks at the wrists of his hands with the small cross-shaped bleeding stigmata.

 STIGMATLER

 (*talking to God*)

Father, I did what I thought you wanted. Now You have to decide where to send the Son of Man.

The landscape, behind his hands, suddenly changes.

SCENE 7. EXTERIOR/DAY - COUNTRY ROAD NEAR POTSDAM.

Behind STIGMATLER's wrists the scenery changed fast, and now he finds himself catapulted into a country road near the German city of POTSDAM, in the Land of Brandenburg. In this street A PROCESSION OF YOUNG NEONAZISTS AND NAZISKINS is celebrating a small reunion. THE NAZIS, aged between 20 and 45, are harangued by A YOUNG MAN, 30 years old, with a shaved head and a crest of black-orange colored hair; he has climbed on a bench placed in front of the SMALL CROWD and he's making a screaming speech.

<div align="center">

YOUNG NAZI

(*shouting*)

</div>

We must continue to work for the Führer! Meet the Führer, guys! The Führer is no longer with us, but we always have him in our hearts. And so it will always be, forever and ever! Amen!

THE GROUP OF NAZISKINS starts shouting with joy. STIGMATLER hides himself in the back of the crowd, leaning against a big-trunk tree.

 STIGMATLER

 (*looking at the sky, talking to God*)

 Father, your Cup becomes more and more
 bitter...

In the meantime, some of the NAZIS turned
themselves and saw that strange figure leaning
against the tree. Everyone begins to look at
each other and nod towards STIGMATLER's
silhouette.

 A SKINHEAD

 Look… Look at that!

 AN OLDER SKINHEAD

 Never seen such an incredible resemblance...

STIGMATLER remains quiet. But THE NAZIS are
already starting to get distracted and looking
insistently in his direction, with surprised
murmuring. Someone tries to advice the YOUNG
NAZI STEEPER who is still shouting his speech.

 YOUNG NAZI

For this reason, O Brothers, we must now choose
 who among us could lead us ...

The YOUNG NAZI stops talking while ANOTHER NAZI
younger than him pulls him by the sleeve and
points to the strange figure of STIGMATLER. The
YOUNG NAZI falls silent. Then he gets off the
bench and makes his way through the small
murmuring crowd. So he gets closer and closer
to STIGMATLER.

 YOUNG NAZI

 (to STIGMATLER)

You! What the hell do you think you are? Did
 you come here to make fun of us?

STIGMATLER is mute. The YOUNG NAZI, followed by
TWO OTHER BULKY NAZISKINS (probably his
bodyguards) approaches him and takes him by the
scruff of the neck, showing a knife.

YOUNG NAZI

(*to STIGMATLER, threatening him with the knife*)

Come on, fucker. Who the fuck are you?

STIGMATLER

(*very quiet*)

I am the Way, the Truth and the Life. My Father, who sees all and is in heaven, sent me here to Earth to…

A MATURE SKINHEAD

One moment! Stop. Don't hurt him. He talks as if he were the Führer!

Some start laughing. The YOUNG NAZI is already wounding STIGMATLER'S neck with his knife, but he notices that the wound, as soon as it opens, heals immediately. The YOUNG NAZI is astonished.

YOUNG NAZI

Jesus Christ…

 STIGMATLER

Yes, I am. You didn't pronounce God's name in
 vain.

The YOUNG NAZI tries to throw his knife at him
again, but it instantly evaporates,
disappearing into the air. The YOUNG NAZI is
scared.

 ANOTHER SKINHEAD

 (*commenting enthusiastically, voice off*)

 Cool!

TWO ELDER SKINHEADS hidden in a corner and are
conversing, not too surprised, in spite of the
situation.

 FIRST ELDER SKINHEAD

 (*mumbling*)

 That's a magician.

 SECOND ELDER SKINHEAD

Let's take him out so we can show everyone that
 he's just a clown.

THE TWO ELDERS giggle, then also approach
STIGMATLER among THE SMALL SILENT CROWD.

 FIRST ELDER SKINHEAD

 (*to STIGMATLER*)

Hey, Dick. Do you remember those holes in your
 hands and feet? Now I'll do one in your
 stomach.

The ELDER SKINHEAD quickly draws a gun and
shoots directly in STIGMATLER'S chest.
STIGMATLER collapses to the ground. The other
NAZIs look at each other a bit frightened; then
they approach the corpse. The gasping
STIGMATLER puts his perpetually bleeding wrists
on his heart, and the hole caused by the bullet
heals immediately, disappearing as quickly as
the wind. The ELDER SKINHEAD with the gun turns
his facial expression from sadistic to horror-
frozen. Meanwhile STIGMATLER gets up quietly.

STIGMATLER

My Father forgives you, because you don't know what you're doing.

So the SKINEHADS fall on their knees one by one, as in a domino effect, all prostrated in front of STIGMATLER. The YOUNG NAZI, the speaker at the beginning, changes his mind.

YOUNG NAZI

My God, I can't believe it! But you are truly the reincarnation of the Führer who returned from the beyond! Our Heavenly Führer!

ANOTHER NAZI

Be careful, it could just be a trick, a shitty A.I. effect!

FIRST SKINEHAD

(*handling his weapon*)

But what a trick! This gun works… he would be already dead as a bug.

AN OLDER NAZI

The powers of Hell sent him here, to Earth, to guide us! Beelzebub and Belial have heard our prayers!

ANOTHER NAZI

Yes, he will lead us towards the New World War and world domination! He can do everything! This guy's Almighty!

ALL THE NAZIS

(*screaming in chorus*)

Heil, Hitler!

THE NAZIS take STIGMATLER and carry him in their arms, and they're full of joy.

THE NAZIS CHORUS

Heil, Hitler! The Führer is among us again! He is back, he can manage with miracles!

 STIGMATLER

 (*attempting in vain to free himself from their
 arms*)

 No, O Brothers, listen to me. It's not what you
 think. My Father sent me here to Earth for
 another reason. There won't be any Third World
 War in my name!

But no one listens to him. The SMALL NAZI CROWD
continues to shout and cheer, lifting him into
the air like a crowd-surfing rock star.

 STIGMATLER

 (*imploring God*)

 Father, please, this is too much. Remove me if
 you can from this mess! But your will be done,
 not mine.

While they are still carrying him towards
POTSDAM, STIGMATLER inexplicably disappears.
The NAZIS didn't even notice it at first sting.
They continue to scream enthusiastically, until
the jubilation is interrupted by one of them.

FIRST SKINHEAD

Hey! One moment. Stop! She slipped away!

SECOND SKINHEAD

That's true! Where has our Führer gone?

YOUNG NAZI

(*The one who gave the speech*)

Don't worry, O Brothers! We will find him again! It won't escape us for a long time.

MATURE NAZI

Yes, we will search him through seas and mountains! Everywhere!

And the NAZIS begin to spread out strategically throughout the countryside.

SCENE 8 . INTERIOR/DAY. STATE OF THE VATICAN. SIGNATURE ROOM.

TWO HIGH PRELATES are watching the web video images of STIGMATLER walking on water on an I-Pad.

> FIRST PRELATE
>
> It's truly amazing what they can do with CGI today!

> SECOND PRELATE
>
> Of course, but this is bad taste. The message is horrible.

> FIRST PRELATE
>
> Has the Pope already been informed?

> SECOND PRELATE
>
> Sure. This afternoon there will be a meeting the Council Hall, we have to discuss this matter.

FIRST PRELATE

Desecrating Faith symbols this way!

SECOND PRELATE

That's also a bad example for young people, an insult for the Official Religion.

FIRST PRELATE

There are some comments from the witnesses of the scene, and they believe it's all real…

SECOND PRELATE

Gullible, or miserable people that only want to fuel controversies and get more followers. What do they hope to achieve? Making the Vatican uncomfortable?

FIRST PRELATE

Actually, we're here talking about it... So it seems they've yet achieved their goal.

SECOND PRELATE

As Representatives of the Holy Roman Church we should issue an encyclical to distance ourselves from this shameful farce.

FIRST PRELATE

I prefer to wait for the Pope's opinion. Perhaps it would be time to start a secret investigation and try to understand who's behind this horrendous and grotesque spectacle.

SCENE 9. EXTERIOR/DAY. WEST BANK. A VILLAGE IN A REMOTE CORNER.

Almost razed to the ground by the war, a small village destroyed by War in a remote corner of the West Bank. GROUPS MEN, WOMEN, CHILDREN, ELDERLY PEOPLE are wandering around the town among the rubble, looking for food or roofs for shelter. Despair and desolation. SOMEONE is filming the ruins with their phone camera. STIGMATLER appears from behind a metal roof thrown to the ground; this is what remains of a small prefab, a former school. STIGMATLER comes out and steps forward. He begins to look around with a sad expression and he sees the GROUPS OF PEOPLE scattered here and there. EVERYONE begins to notice his presence and strangely look at him. STIGMATLER doesn't care, until an ISRAELI MAN (about 50 years old) who lost everything because of the war, starts to call him.

ISRAELI MAN

(*to STIGMATLER*)

You! Do you think we're having a party?

STIGMATLER doesn't respond. The ISRAELI MAN then approaches him.

> ISRAELI MAN
>
> (*to STIGMATLER*)
>
> Hey! I told you! Can't you see what's going on around here? Do you think it's time to joke and provoke?

> STIGMATLER
>
> (*very quietly*)
>
> My Father sent me here for a reason. He sent me here to help you.

SOME PEOPLE are beginning to grin secretly. But STIGMATLER is unfazed.

 STIGMATLER

I am the Way, the Truth and the Life. Whoever
lives and believes in me will never die.

PEOPLE continue to look each other strangely,
while SOME OF THEM sadly chuckling. A VEILED
ELDERLY WOMAN, limping, without a leg torn away
by a bomb explosion, starts to talk.

 ELDERLY WOMAN

At least there's someone spouting bullshits who
 puts us in a good mood!

 ISRAELI MAN

 (*to the ELDERLY WOMAN*)

 Don't joke! Can't you see how we are? And
you're laughing at this Nazis leader-dressed
clown? we must rather chase him away or kill
 him...

A small chorus of unanimous voices rises up and
seems to agree with the ISRAELI MAN.

STIGMATLER

(*calming the spirits*)

Please, please… We are all Brothers. I came here to give you peace, even if not like the world gives it to you.

Apart, TWO BOYS bleeding and with torn and dirty clothes, are meanwhile watching the video of STIGMATLER walking on the water on their cell phone screens.

FIRST BOY

(*to the SECOND BOY*)

Hey! But… I've seen that guy before!

SECOND BOY

How did he get here from the sea?

ISRAELI MAN

(*to STIGMATLER*)

That's enough! Get out of here if you don't want us to call the police!

STIGMATLER

I understand your dismay surprise, O Brothers. Don't worry, I repeat, I'm here to help.

ELDERLY VEILED WOMAN

(*to PEOPLE*)

He is here to help us. And how?

(*to STIGMATLER*)

Can't you see we have nothing? The war took everything away, even our dignity!

STIGMATLER

(*seriously; something like a halo appears around his head*)

Well, I promise you: in just 3 days I'll rebuild your small destroyed village.

People start laughing sadly.

ISREALIAN MAN

(angry)

Did you hear him? He rebuilds the country in 3 days! Goddamn him! Disappear, if you don't want me to bury you under the ruins.

But one of the TWO KIDS watching the video starts to speak.

FIRST BOY

Stop! Watch! Online he's famous for this!

(Showing everyone the phone screen with the web video of STIGMATLER walking on water)

You see! It's not a joke!

ELDERLY VEILED WOMAN

(to the FIRST BOY)

You still believe in fairy tales, you! Ever heard of A.I.?! This impostor is looking for publicity! People no longer know what to invent to become famous!

STIGMATLER

It is written: You shall not mock the Lord Your God. And I promise you that in 3 days this village will be back to life, you will have your homes again, and enough food and clothes. Have faith. Even just as much as a mustard seed has...

SECOND BOY

He's the Messiah! He's back on Earth again! Some said so, in the comments on the video! His name is <u>Stigmatler</u>!

ISRAELI MAN

Shut up, you idiot kid! Now I've lost my patience!

(*to* PEOPLE)

Get rid of him!

PEOPLE have gathered in a small group and, in spite of their dim fury, they rush like a small crowd on STIGMATLER, incited by the ISRAELI MAN. But they only end up fighting pointlessly and hurting each other, because STIGMATLER has disappeared.

ANOTHER MAN

Stop! The motherfucker is gone!

The SMALL GROUP OF FOLKS quickly disperses.

ELDERLY WOMAN
(*sarcastic*)
Shitty and hateful clown! I'll make a miracle for him by myself!

SCENE 10. EXTERIOR/NIGHT. WEST BANK. THE VILLAGE IN A REMOTE CORNER.

Overlay Title:

THREE DAYS LATER

Disinherited ISREALIANS are sleeping on the ground. It's 5.30 in the morning but it's still quite dark. ONE OF THE TWO KIDS with the phones wakes up early and starts rubbing his eyes. Looking around, his facial expression is filled with wonder: despite the pale darkness, he sees that the small village is identical to before. Perfectly rebuilt and functioning, as if there had never been any war. The LITTLE BOY stands up and begins to scream, to tug at the others, including the ISRAELI MAN, that are all sleeping crowded together on the soil.

THE BOY

(screaming with joy and amazement)

Wake up, wake up every one! Watch! Hurry up, hurry up!

ANNOYED PEOPLE slowly begins to get up.

 A YOUNG DOCTOR
 What you want, dude?! Let us sleep…

But now ALMOST EVERYONE is standing up. The
light of dawn begins to filter from behind the
buildings and houses, now perfectly
reconstructed. Everything looks brand new. The
WEST BANKERS are increasingly astonished. The
ELDERLY VEILED WOMAN without a gets out with a
scream of terror and disbelief, then she
collapses to the ground for heart attack. The
amazement of the PEOPLE is such that no one
realizes that she has just died.

 ANOTHER MAN
 I cannot believe it! It's just an illusion! It
 is not true!

 FIRST BOY
 Stigmatler was right! He is a superhero.

 ISRAELI MAN

My eyes cannot believe! Our homes... Everything
 is back to life... It can't be real. Be
 careful! When the light returns we'll go in
 exploration.

But the light has already returned, almost before sunrise: another unexplained phenomenon. The SMALL CROWD breaks up and, scattering, everyone enter their homes, whose doors have remained half-opened, as if they were yet ready to welcome them.

SCENE 11. INTERIOR/DAY. THE VILLAGE IN THE WEST BANK. HOUSE OF THE ISRAELI MAN

THE ISRAELI MAN, the most incredulous of all, enters his apartment and finds everything perfectly intact. What's more: everything seems brand new, even if there are objects that have been familiar to him for a lifetime. A WOMAN, probably his relative, follows him. He sits on a sofa, astonished.

ISRAELI MAN

No, it's impossible. There's something underneath.

WOMAN

The veiled woman died of fright.

ISRAELI MAN

Where ... Where did that guy go?

 WOMAN

Nobody saw him anymore. I told you: that woman
 of the village just died!

 ISRAELI MAN

So maybe that man... He really came in the name
of God to liberate us... But why did he look so
 much like the dictator... I don't understand.

The WOMAN sits on the coach and stares at him
intensely with a loving and understanding gaze.

 WOMAN

 (*quoting a Gospel phrase by memory*)

"If they do not hear Moses and the prophets,
neither will they be persuaded though one rise
from the dead".

SCENE 12. INTERIOR/DAY. TELEVISION STUDIES.

VICKY PUSSONTY is a journalist and influencer with 10 million followers (on the Troja-gram and Muffle-book apps), a tall, sporty and slender career woman, very seductive and calculating. She is sitting in the editorial office of the TV show she hosts (WHAT-THE-HELL? It's called), a Tv & Web show which has recently suffered a significant audience decline. VICKY sits in front of an Apple laptop; her boss, ARBOGAST, walks nervously around her. He is a 65-year-old man, with a rough look, slightly overweight. He is angry with the situation.

ARBOGAST

(*walking nervously around*)

If we continue with a 3 percent share, Sponsors will mow our asses... As early as next week.

VICKY

(*ferocious*)

Don't go up and down like that, Roy. My brain can't stand it.

ARBOGAST

Here I decide what you can stand or not. 10 million of fake followers?

VICKY

(handling her cell phone while looking her Trojagram profile with 10M followers)

I'm the one who got you a 30 percent share in past years.

ARBOGAST

Fuck the bygone years, Vicky. We need to catch up now. We're almost in a pinch. My wife has yet threatened to leave me.

VICKY

(*sarcastically*)

Finally.

ARBOGAST

No time for kidding.

VICKY

(*starting to watch STIGMATLER's online video through her Mac*)

Talking 'bout kidding. Look here.

(*showing Arbogast the video*)

What do you say?

ARBOGAST

Who knows what tricks they used. What a colossal bullshit.

VICKY

Sure it looks tremendously realistic… I didn't think those CGI hackers had outclassed Hollywood special effects.

ARBOGAST

Stop playing, Vicky. We have to find a scoop by Sunday, time is running out.

 VICKY

People talk about it, the comments… There are
eyewitnesses. They say he brought back to life
a woman. After all, it's a video taken with a
 phone camera...

ARBOGAST does not respond, wiping the sweat
from his forehead with a handkerchief and
continues to walk around in icy despair.

 ARBOGAST

We could recover the story of that tiger shark
that attacked a dwarf off the coast of Cebu...
Or we can invent something. A father happy that
his daughter's former boyfriend killed her
because he later realized she was a bitch?

 VICKY

So we'll be completely deleted just tomorrow.
Come on, Roy. I wish to dig deeper into this
story. I want to go and see. Look here.

(*VICKY shows pictures of the rubble in the West Bank of the day before, and what the country has now become, after Stigmatler's intervention*)

It's already over a million views. People talk about it... But on TV no one has done a report on this yet... Stigma-tler.

ARBOGAST

Stigma… What?

VICKY

Let me try, Roy. Send me to that beach with Guno, and I'll try to talk to those witnesses.

ARBOGAST

Firstly contact them via social media. Search their profiles and ask them two or three questions.

VICKY

It won't work, Arbogast, they wouldn't answer me... I have to see them live. They're inhabitants of that zone.

ARBOGAST

Ugh, how persistent you are. But if you fail, consider yourself fired.

VICKY

It won't happen, Roy. We need to find out who is this Hitler-looking guy making miracles and talking like Jesus Christ. It may be a hoax, ok, but we will be the first to expose it.

ARBOGAST

Of course it's a hoax, don't you see?

VICKY

But it would get ratings. We'll be the first TV transmission to be interested in him...

ARBOGAST

What do you know that we are the first? That slut Tonia might have had the same thought.

VICKY

Forget Tonia, Roy. She's a dim witch. I'm still the number one.

ARBOGAST

All right Vicky, take Guno and go. I'll book the plane for you. But I want you back by tomorrow evening, and with some good stuff. Or there'll be hell to pay. Deal?

VICKY closes the laptop, stands up and kisses ARBOGAST on the cheeks, smiling at him and giving him a quick hug.

VICKY

I always knew you were a big asshole and also a great man.

VICKY leaves in a hurry, while ARBOGAST is sitting at his PC; he remains doubtful comparing the photos posted on Muffle-book of the West Bank village destroyed by the war, now reconstructed in few days.

SCENE 13. EXTERIOR/DAY. GOBI DESERT

STIGMATLER is now in the Gobi Desert. Dunes, Wind, Oases: the nothingness. Some snakes. STIGMATLER looks towards the sky imploring God.

 STIGMATLER

 (*talking to God, whispering*)

 My Father, who are in heaven, why have you
 brought me here? Which test will I have to face
 now?

STIGMATLER looks at his hands with bloody wrists and cross-shaped stigmata. He is thirsty, so he starts to suck and drink his own blood using lips, like a vampire. Then he raises his head and sees indistinctly a man coming towards him. The closer he gets, the more STIGMATLER begins to recognize him: he's identical to JESUS CHRIST. But the fact is that STIGMATLER is the real Christ, even if he looks like Adolf Hitler. So STIGMATLER is baffled. The CHRIST stops in front of him; he is visibly shaken by fatigue and dehydrated by the hot climate.

STIGMATLER

Who are you? Who sends you?

JESUS CHRIST

I am the Way, the Truth, the Life. Whoever lives and believes in me will never die. Who are you?

STIGMATLER

You're wrong. I am the Christ, the Anointed of the Lord, the Only Begotten Son. God sent me back on Earth for teaching to humans…

JESUS CHRIST

(*abruptly interrupting him*)

Shut up, evil impostor! You are the Devil! Evil Incarnate. The Führer, the Absolute Dictator. You're the Antichrist!

STIGMATLER

No, you're wrong. God gave me this look to teach humanity to love even negative appearances; to know how to recognize the Good even where we would never expect to find it.

JESUS CHRIST

Hypocrite! There's no way you can buy me. The Heavenly Father sent me to you precisely to dissuade you from this crazy stupid mission! You won't dare to go around the world doing miracles and preaching love this way anymore!

STIGMATLER

Well, I have in myself the evidence of My Father's Love and Truthfulness.

(*Showing his bloody cross stigmata*)

JESUS CHRIST

(*not impressed*)

You are certainly hurt by yourself. Just like some wannabe saints did.

STIGMATLER

Blasphemy. Tell me, where are you from? Who really sends you?

JESUS CHRIST

I've already said. I am here by will of Lord, the only One: my Father who reigns in the kingdom of heaven. It is time for you to depart from this world forever and let me to complete the mission successfully.

STIGMATLER

And what should I do, in your opinion?

JESUS CHRIST

God the Father commanded that you follow me to the top of a hill nearby. From there you will have to jump down. Don't be afraid, if you too are truly the Son of Man, you won't smash.

STIGMATLER

I feel like I've already experienced this moment a long time ago. It was just a little bit different…

JESUS CHRIST

Come on, stop babbling and follow me to the top of that hill!

(*He points with his head to a hill not far from them*)

When your soul will be returned to the darkness from which it came, humans won't hesitate to recognize me as the true Messiah.

STIGMATLER

No, there's something not working right. My Father wouldn't ever order to anyone to commit suicide like this.

JESUS CHRIST

Didn't I commit suicide on the cross, two thousand years ago, to save all mankind, including you? And I didn't oppose myself to the will of the Almighty, you know.

STIGMATLER

(*as if suddenly recovering*)

Get away from me, Satan! You, how dare you take my form wandering in the desert and come here to tempt me?

JESUS CHRIST

Woosh, then I would be the Devil!

(*suddenly his eyes turn black as pitch*)

And you, Only Begotten Son, how dare you take one of my shapes and wander around preaching the Divine Word?

STIGMATLER rapidly stands up. Now in front of him there is no longer the man looking like JESUS CHRIST, but a DEMON, a black whirlwind of indefinite horror that swirls in the air with enormous power.

 STIGMATLER

Was the Lord who sent you to me for testing me with temptation? Well, I recognized you, Satan! Let's return to the dark depths of Hell immediately!

 DEMON (ILVASTOR)

This time you discovered me, but don't think it's over here. I will return again and again. Evil is eternal as Good.

 STIGMATLER

(*showing with energy the two bloody crosses on his wrists, from which a singular light is now coming out*)

Get out! Get lost! And may you continue to be damned forever and ever.

The DEMON/ILVASTOR swirls around again and again, looking very terrifying. Then he is swallowed up by a whirlpool of desert sand, that makes him disappear in the dust. Calm returns in the landscape. STIGMATLER is exhausted, so he leans on a rock.

SCENE 14. EXTERIOR/ NIGHT. GOBI DESERT

STIGMATLER is still wandering in the desert. He is exhausted because of the fight against the Devil. There are no living souls around. STIGMATLER approaches to an oasis and drinks the clear water, then he leans against a palm tree and looks the moon shining in the sky.

> STIGMATLER
>
> (*to God*)
>
> Father, I have recognized and won the power of darkness for now. My loneliness becomes greater and greater. I beg you, Father, help me if you. This pain is so tough and devastating to me.

At this point STIGMATLER hears strong wind blasts coming in the opposite direction of his little camping. He turns and sees an immense whirlwind, similar in shape to that of the Demon, coming all over himself. Horrified, he starts to pray as the cyclone gets closer and closer and finally overwhelms him, sucking STIGMATLER into a gray vortex that rises up to the sky.

SCENE 15. EXTERIOR/DAY. LUXURIOUS MANOR.

A very luxurious villa with outdoor swimming pool, probably in the south of Italy, in a sunny area. Huge palm trees provide shade. STIGMATLER finds himself catapulted in front of the manor's large gate.

> STIGMATLER
> (*looking the sky*)
> Perhaps the desert was better...

STIGMATLER hears Doberman dogs barking not far away from him. Then he places his bloody stigmata against the lock of the gate (there are no names on the doorbell) and it opens by clicking. STIGMATLER enters inside the manor. The Dobermans suddenly stopped barking and they don't come to attack him. STIGMATLER moves quietly along the edge of the outdoor swimming pool, until he arrives in front of an arcade with glasses. This is the entrance. STIGMATLER hears someone conversing and murmuring on the other side of the glass windows. Then a door opens and a VERY BEAUTIFUL WOMAN comes out, in a corset and dark lingerie, she seems a super model influencer. The WOMAN surprised looks at STIGMATLER. She's got a very expensive latest generation iPhone in her hands.

WOMAN

(*to STIGMATLER*)

And where the hell'd you blast from?

(*THE WOMAN is looking at the screen of her iPhone while STIGMATLER is trying to enter the Manor, ignoring her*)

Hey, stop for a moment! I know you. You're that guy everyone's talking about! The one who makes miracles! I saw you on the web, aren't you Stigmatler, don't you?

STIGMATLER

Be quiet, woman. Don't bother me.

WOMAN

(*standing in front of STIGMATLER with sensuous moves*)

Hey, stop! How did you manage to get in here? This shouldn't be possible. Look, those guys up there will kill you out!

STIGMATLER

...

WOMAN

All right, come on. Let's take a selfie!

(*THE WOMAN tries to be embraced by him, but he doesn't react*)

Are you always so icy piece with girls? What do you want to do now?

STIGMATLER

Leave me, woman. The Holy Spirit brought me here.

STIGMATLER wriggles. The WOMAN follows him.

WOMAN

Hey! Are you fucking crazy?.

SCENE 16. INTERIOR/DAY. LARGE LUXURY MANOR. ATRIUM

STIGMATLER, got free from the WOMAN's grip, goes on in the big atrium of the manor. There's a spiral staircase in front of him. The WOMAN, now in hurry and with no longer sensuous movements, follows him and tries to stop him.

 WOMAN

Look, I'm saying it for your sake! They're in a meeting up there and they're not joking! They will kill you!

 STIGMATLER

I fear no Evil, especially by men.

 WOMAN

 (*taking STIGMATLER'S arm*)

Look, I've always wanted to make love with a very famous man like you. Why don't you come in the bedroom? It'll be funny.

STIGMATLER

It is in the Writings: Man shall not live by *breast* alone ... And now let me go, woman.

(*He goes on gently, freeing himself from her grip*)

STIGMATLER climbs the steps, while the WOMAN remains at the bottom of the staircase.

WOMAN

As you prefer ... I warned you!

SCENE 17. INTERIOR/DAY. MANOR'S CENTRAL ROOM

In a large luxurious room, full of expensive rugs and paintings, there is a central round table, around which 12 MAFIA LEADERS are in a secret meeting. They are fully dressed in very elegant tuxedos, and their age is from 35 to 55. They are talking with very low voice: an indistinct murmur can be heard. When STIGMATLER appears in front of the table around which they are in reunion, everyone turns towards him and looks at him with alarmed facial expression. ONE of them takes a gun from his pocket and pointing it against STIGMATLER.

 STIGMATLER

(putting hands up like surrender)

O Brothers, please remain seated and stay calm. The Heavenly Father has sent me to you to announce the "Good Book".

 MAFIAMAN WITH GUN

(standing up and keeping the gun against STIGMATLER)

Who are you? Who let you in?

ANOTHER MAFIOUS

It must have been your slut!

MAFIAMAN WITH GUN

Shut up!

(*He still points the gun against STIGMATLER*)

Get out of here, now. Or I'll send you in the beyond.

STIGMATLER

I was just there few days ago.

(*with open arms*)

Matteo, Salvatore, Bernardo, Marco... I came here in the name of God. The God you believe in.

ANOTHER MAFIOUS

(*to the OTHER BYSTANDERS*)

How does he know our names? In the state someone set us up?!

A MAFIA MAN

Wait. I saw him on video this morning. There's lots of talk about this guy all over the web. He pretends to make miracles.

A MAFIA LEADER

Let's strike him right now!

STIGMATLER

The Lord sent me to you for you'll become fishers of men. Lay down your weapons and follow me. This is the only way to get freedom. And great will be your reward in Heaven.

ANOTHER MAFIOUS

(*spitting on the ground*)

But who does believe he's the Messiah? Looking like this …

ANOTHER MAFIA LEADER

It's true. I saw the video too! He walked on water, and resurrected a drowned woman. In three days he rebuilt a country destroyed by war. If this was true …

STIGMATLER

You'll become my disciples. Do not refuse the Holy Spirit call. I came here not to bring peace, but the sword.

A MAFIA MAN

We don't use swords, only silenced weapons, and sulfuric acid if necessary.

ANOTHER MAFIA LEADER

Good idea! Let's melt him in the tank!

THE MAFIAMAN WITH GUN hits STIGMATLER just below the chest with a single bullet, and he collapses to the ground. The SMALL GROUP OF 12 MAFIOS surrounds him. 6 OF THEM take STIGMATLER and carry him out of the central room, and then down the spiral staircase.

18. INTERIOR/DAY. THE MANOR. SPIRAL STAIRCASE AND HALL.

THE MAFIA MEN go down the steps. 6 OF THEM are carrying the unconscious STIGMATLER. They carefully go down into the hall. THE WOMAN, who has already understood what is about to happen, terrified looks at them. ONE OF THEM approaches her and slaps her on face.

> MAFIOUS
> (to the WOMAN)
> We'll deal with you later, bitch.

THE WOMAN hides in a corner of the hall, without saying a word. The 12 MAFIA MEN head towards the basement, then stopping in front of a closed door that leads to the basement.

SCENE 19. INTERIOR/NIGHT. MANOR'S BASEMENT.

THE MAFIA MEN carry STIGMATLER's body down a small dark staircase, then land in a cellar-like room, lit only by a dim lamp hanging from the ceiling. They put STIGMATLER's body on the pavement. The oscillating light bulb (one of them hit his head against it) illuminates a big tank in a completely bare environment; the tank is filled with sulfuric acid. THE MAFIA MEN remain in silence for a moment, then ONE OF THEM speaks.

 A MAFIA MAN

 Let's give him a bath.

They lift up STIGMATLER and, with a small run-up, 6 OF THEM throw him into the acid. They move away quickly to avoid the splashes. The water begins to boil exhaling strange vapors. MANY OF THEM watch the show with satisfaction, but some are doubtful.

 ANOTHER MAFIOUS

We made a mistake! He was Stigmatler. It could
 have been useful to us.

The acid stops bubbling. A MAFIA LEADER
approaches to the tank. He sees that
STIGMATLER's corpse is perfectly intact. His
face takes on an expression between amazed and
horrified somehow.

 MAFIA LEADER

 (to OTHERS)

Hey, look! He didn't melt at all, 'come on, you
 fuckers!

One by one they get closer pushing each other,
and remaining at the edge of the tub.

 ANOTHER MAFIOUS

 I can't believe that! I can't believe that!

 A MAFIAMAN

 (*astonished*)

 Never saw something like that... Who is he?

 A MAFIA LEADER

 Watch!

 STIGMATLER standing in the acid opens his eyes
 and stares at them. Then he gets up from the
 liquid-filled tub as the others all move away
 huddling against the wall, and they're full of
 horror. The light bulb twirls around the room
 illuminating here and there, because it has
 been hit too many times by headbutts.
 STIGMATLER comes out of the tank perfectly
 sane.

 STIGMATLER

 Why don't you believe me, men without faith!
 From today a new life is beginning for you all.

TWO OR THREE OF THEM begin to fall on their knees. ONE MAFIA LEADER tries to escape by climbing up the dark staircase, but trips and falls backwards. ANOTHER ONE has followed him but when he reaches the door he realizes that is locked.

 STIGMATLER

I am the Way, the Truth and the Life. The Lord who is in heaven has decided you to become my apostles. From now on you will come with me everywhere, and you'll be like lambs.

 A MAFIA MAN

 (falling on his knees to the ground)

 Master! I believe you!

THE 12 MAFIA MEN start to make any resistance, as if a exogenous force was pushing them to convert. They have fallen on their knees and STIGMATLER baptizes them one by one with sulfuric acid, which doesn't hurt anyone.

A MAFIA LEADER

Yes, I will follow you, Master! You're back again, you are the Begotten Son who has come to break the chains of Evil!

ANOTHER MAFIOUS

I want to follow you too. I regret I have sinned against God and against men. Take me with you, Master, and forgive me.

STIGMATLER

Truly I say to you: many of the sins of men will be forgiven.

THE MAFIA MEN, amazed by the miracle and gradually overcoming every fear are now ready to follow STIGMATLER. An unnatural light, probably sent by the Holy Spirit, pervades the small underground room.

SCENE 20. INTERIOR/DAY. TONIA'S TV STUDIO.

The Tv journalist and influencer TONIA, a very attractive brunette woman, 30 years old, is checking her PC monitor sitting at the desk and watching the Stigmatler web video. She reads people's incredulous comments. A JOURNALIST, her subordinate and COWORKER, is behind her. He's a guy about 60 years old, bald melancholic man.

 COWORKER

Tonia, you've been sitting there for 3 hours. Can we find out what's wrong with you?

 TONIA

Don't wrinkle, Gecko. There's something bigger.

 COWORKER

 And what is it about?

TONIA

Stigmatler.

COWORKER

That clown dressed like Hitler who pretends to be the new Messiah?

TONIA

Clown or not, it could be the scoop of the century. On Troja-gram it has yet done over one million views…

COWORKER

Surely Vicky is already involved with that shit.

TONIA

Of course. So what?

COWORKER

I don't think it's worth it, you know.

TONIA

Look, do you want me to report you for sex harassment like I did to the guy who worked in this studio before you?

COWORKER

That would be a good opportunity to me for no longer suffering your psychological harassment. And change my life.

TONIA

(*showing him the studio exit*)

That's the door!

COWORKER

All right, you won. I'll try to discover if Vicky has also fallen into the trap.

 TONIA
 Yes, and do it quickly, you idiot.

The COWORKER walks away, while TONIA begins a
web search for the news regarding her colleague
and enemy Vicky Pussonty.

SCENE 21. EXTERIOR/DAY. A CLIFF ON THE SEA.

STIGMATLER performs the official naming rite of his brand new disciples. The 12 MAFIA LEADERS have now become the 12 APOSTLES. Always dressed as mafia men, but with a totally opposite attitude. All gathered around him, they sit on the ground while the sea waves rage in a small storm.

 STIGMATLER

 (*in a solemn tone*)

In the name of God I baptize you with your new
 names: Himmler, Goebbels, Göring, Hess,
 Bormann, Rosenberg, Ribbentrop, Speer,
 Eichmann, Axmann, Priebke, Schreck.

As they are named, the APOSTLES stand up one by one. The expressions on their faces have changed: the hardness of their gazes has now become pious sweetness.

 EICHMANN

 Master! What will we do now?

 STIGMATLER

 ...

SCENE NA 22. EXTERIOR/DAY. BEACH.

VICKY arrives with her cameraman GUNO, a blond guy 30 years old, on the beach where STIGMATLER appeared for the first time. She manages to gather there SIX WITNESSES that have seen the Messiah for the first time and the drowned woman's resurrection. VICKY talks to them, gathered in a group around her, giving instructions on how the interviews for the TV show "WHAT-THE-HELL?" will take place.

VICKY

Well, since you were the eyewitnesses of these 2 miracles, we must organize as you have been interviewed very few time after the Jesus Hitler disappeared. The drowned woman? Isn't she here anymore? And Did someone record the scene on a mobile phone?

A MAN

I was here. The drowned girl left immediately and by the way she doesn't want to be interviewed.

 A WOMAN

The girl who posted the walking-on-the-water
video has all her social profiles deactivated
 now. We don't know what happened to her.

 VICKY

 (*displaced*)

Okay, let's forget about it. I'm just hoping
that Stigmatler didn't force anyone to stay
 mute.

 A BOY

Why would he? We saw the miracles, everything
was authentic. There wasn't A.I. or CGI.

 GUNO

Who knows? Today you can do the impossible,
 thanks to special effects.

 VICKY
 (*tough*)

You're here to shoot, not for asking questions.
 I'm the boss.

 (*to THE BYSTANDERS*)

So, one by one, you pose in front of the sea, I
want the background to be exactly the point of
 the shore where the guy landed, ok?

PEOPLE nod. At that moment VICKY's mobile phone
starts ringing.

 VICKY

 (*cursing, watching the sky*)

God Christ! But what fuck does he want now? I
 don't answer...

 GUNO

 (*to Vicky*)

 If he calls, there's something urgent.

 VICKY

 (*snorting, answering the phone*)

Yes, Roy… What is it now? Oh Jesus Christ, no …
No IMMIGRANTS, please. I don't give a shit! I'm
tired to serve those fucking politics. Fuck!

 ARBOGAST

 (*voice off, on the other side of the phone*)

Look Vicky, I don't make the rules. You have to
go there immediately to record the IMMIGRANTS'
 arrival on the coast. Just right now!

 VICKY

 Ugh, Roy…

 ARBOGAST

 (*voice on the phone*)

Don't discuss, Vicky, or I'm going to fire you.
 I told you it was useless to go there, that
 clown wouldn't appear again.

VICKY

But I have got all the witnesses here... It would still be a bombshell, these people saw everything with their own eyes!

ARBOGAST

(*voice on the phone*)

I don't want to argue any more. You and Guno drop everything and pack your bags right away. I have already booked the flight at 2 PM for you, at 4pm you will have to be on that coast with the IMMIGRANTS.

(*Arbogast ends the call*)

VICKY looks at GUNO, who had already held the video camera and was preparing to film the EYEWITNESSES, with a disappointed and disconsolate expression.

GUNO

Oh, Gee. Can we find out what's happening?

VICKY

Drop everything. We have to leave and get the boats arriving on the coasts of the other island. The usual shitty report to show everyone we are good people.

GUNO

Oh, okay, I get it, Chief. Let's move.

GUNO closes the viewfinder of the camera and begins to put it in a bag. VICKY turns off the microphone.

A BOY

Hey, where are you going? You made us come here specifically for the interviews!

VICKY

I apologize. Unpredictable disguise. But we will return…

VICKY and GUNO rapidly get into their car parked nearby and disappear with the speed of light, leaving the small group of WITNESSES alone and perplexed.

 A WOMAN
 Kind of fucking idiots!

SCENE 23. EXTERIOR/DAY. ON THE COAST OF THE IMMIGRANTS' LANDINGS

Dinghies full of IMMIGRANTS, MEN, WOMEN AND CHILDREN, coming from Africa, are landing on the beaches. There are several NGO VOLUNTEERS, WOMEN AND MEN that are welcoming them. CAMERAMEN and JOURNALISTS from some TV channels have already arrived on the shore, and behind them there is a SMALL CROWD OF CURIOUS PEOPLE. Meanwhile, not far from this scene, STIGMATLER and his 12 APOSTLES are going on. A red car parks not far from the beach, and VICKY and GUNO get out. They are arriving at the beach when GUNO notices the coming of STIGMATLER with the 12 DISCIPLES (they're all still in the uniform of mafia leaders).

GUNO

(*to Vicky*)

Vicky, look!

(*Pointing out STIGMATLER's weird gang*)

We didn't come here just for them!

 VICKY

This is a sign! Get ready to film it all!

VICKY and GUNO stand in a corner of the beach so as to be able to film unobserved the arrival of STIGMATLER and HIS MEN. Even the IMMIGRANTS, the NGO VOLUNTEERS, the CURIOUS FOLKS that have arrived there and OTHER TV JOURNALISTS notice that STIGMATLER is advancing followed by those MAFIA LEADERS LOOKING 12 GUYS. Then STIGMATLER and HIS APOSTLES stop in front of the IMMIGRANTS.

 STIGMATLER

Don't worry, O Brothers, we came to help you!

 (*talking to GOEBBELS*)

Goebbels! You, enter the water and catch the first fish swimming around you.

ALL THE BYSTANDERS are disoriented.

GOEBBELS

But Master, fishes are not so easily to be caught...

STIGMATLER

Do as I tell you.

(*Then turns to GOERING*)

You, Goering, go to the bar nearby and buy a piece of bread! And ask for a very large basket case.

GOERING

I most certainly will, My Lord.

GOEBBELS enters the water under the astonished gaze of all THE PEOPLE and in fact ONE HAKE immediately approaches his legs and is easily caught by him. Meanwhile GOERING returned from the bar with a large wicker basket with a single piece of bread inside. GOEBBELS brings the fish to STIGMATLER who places it alive in the basket case together with the bread. Then STIGMATLER imposes his small cross-shaped stigmata on that stuff. VICKY and GUNO are silently watching the scene. GUNO is filming.

 VICKY
 (to GUNO, softly)
 Shoot it all, please ... Right all!

In a flash, a myriad of hakes and loaves come out of the wicker basket case.

 STIGMATLER
 (to the IMMIGRANTS)
 Step forward, O Brothers. I know you're hungry. All this is for you. Don't be afraid!

The IMMIGRANTS - even if they're a bit frightened - are approaching the basket and beginning to take loaves and lifeless fishes and put them in their pants pockets or wrap them in pieces of paper they've got with themselves. Everyone begins to smile showing gratitude towards STIGMATLER. SOME IMMIGRANTS bow and kiss his wrapped-in-dark -leather-boots feet. SOMEONE FROM THE CROWD is commenting the scene.

A WOMAN

It's a miracle!

A CHILD

He's a superhero!

A BEGGAR

Nope, he's STIGMATLER! He's the Messiah who returned to Earth for the love of the last ones! Don't be fooled by his look, Folks!

Even the DISCIPLES are amazed by the miracle. Meanwhile among the BYSTANDERS, A MAN BLACK-DRESSED is coming, he's got a hood which covers part of his face. He's a very handsome man, with an athletic physique and rough marked facial features. He's A SMUGGLER. The SMUGGLER is observed by VICKY, obviously due to his physical appearance. She is intrigued by that guy, but she tries not to get distracted from her work.

VICKY

(*to GUNO*)

Did you film everything?

At that moment STIGMATLER starts to makes signs towards the sky. A great light appears, followed by a sort of phantom bubble with an ethereal city inside; this city is made of emerald and it is changing colors continuously. The celestial city glides over everyone's heads and stops above the IMMIGRANTS while they are still taking the multiplied loaves and fishes. ALL THE PEOPLE amazed look towards the sky.

SCHRECK

(*to STIGMATLER*)
Master! What is that?

GOEBBELS

I'm scared!

STIGMATLER

(*to IMMIGRANTS*)

O Brothers, this is the home that My Heavenly Father and myself have prepared for you.

ONE BLACK IMMIGRANT

So what do we have to do now, Master?

An ethereal and spiritual staircase extends from the celestial city. STIGMATLER makes the IMMIGRANTS go up that ladder. Although a bit fearful, BLACK MEN, WOMEN and CHILDREN gradually begin to climb the transparent steps leading them to their celestial houses. A sumptuous city full of palaces and homes, and you can see only the exteriors of it. THE WHOLE CROWD watches the event completely astonished. When ALL THE IMMIGRANTS have climbed onto the city and entered their homes, the staircase suddenly closes and the city starts to twirl in the sky remaining suspended on the landing coast.

STIGMATLER

(to ALL THE PEOPLE)

You see? No one will ever be able to say that they come here to steal your jobs. That city created by the Lord will host and feed them so that they won't have to ask you for anything.

Then STIGMATLER is going to walk away, followed by the 12 DISCIPLES. VICKY starts to run followed by GUNO and tries to stop him. But STIGMATLER and his men are yet disappeared.

 VICKY
 (*cursing at the Sky*)
 Fuck Christ! I wanted to get him! We missed
 again!

 A MAN
 (*from the crowd, concerning Stigmatler*)
 But how come he did it?

In the meantime ALL THE PEOPLE keep on to watch the twirling celestial city in the sky with the IMMIGRANTS inside. The handsome SMUGGLER who also observed the scene disappears into the crowd.

SCENE 24. EXTERIOR/DAY. ON THE BATHSHEET

Back at the parked car VICKY and GUNO stop panting and try to recover from the shock.

> VICKY
> (*to GUNO*)
> Let me see that footage!

GUNO rewinds the footage from the beginning and shows it to VICKY in the camera's viewfinder, but when they are going to watch the whole shooting, they both realize with horror that the camera didn't capture anything. They only see a blank screen with white noise and incomprehensible audio fragments.

> VICKY
>
> Shit face dumbass! What the fuck is that? You didn't get anything!

GUNO

I don't know, Chief, it's unbelievable... I saw everything through the viewfinder while I was shooting... I don't understand...

VICKY

Go to Hell! For you're an ill-cock, up yours! Jesus Christ, we lost the greatest shoot of our fucking careers!

GUNO

Keep calm! Maybe this kind of supernatural things refuse to be filmed…

VICKY

So how do you explain the lady on the beach shot and posted it everywhere? She can and we cannot? Blast it, you snolly-ghoster, you're fired!

 GUNO
 (*timidly*)
 Only Arbogast can fire me.

 VICKY
 Get lost, asshole! Go fuck yourself, or I'll
 stick that camera up your groins!

They are about to fight when another car
arrives on the spot. TONIA and her operator,
ETZIUS, get out and immediately see the scene.
A little further away from them there is THE
SMUGGLER who observes it all laughing.

 TONIA
 (*to VICKY*)
 Hey, Vicky! You fucked up your mind?

VICKY and GUNO stop arguing and stare at TONIA
and her COWORKER.

> VICKY
>
> (*to* TONIA)
>
> You arrived late.

> TONIA
>
> What happened?

> VICKY
>
> Stigmatler multiplied breads and fishes for the IMMIGRANTS on the beach. Then he created that kind of celestial city which is circling in the air above us, but we couldn't record anything!

> TONIA
>
> I don't believe it ... How is it possible?

VICKY shows to TONIA the transparent bubble with the ethereal city inside which in fact can still be seen above their heads.

 TONIA
 (to ETZIUS)
Film it, asshole! What are you waiting for??

ETZIUS immediately grabs the camera and begins to film the miracle.

 GUNO
 It's useless. You won't see anything.

 VICKY
Shut up, idiot! For God's sake, I'm so hellish
 pissed. I need a drink…

VICKY walks away while TONIA and GUNO remain looking at each other perplexed, and ETZIUS continues to film the celestial city in the sky.

SCENE 25. INTERIOR/DAY. BEACH BAR

VICKY still looks rather agitated and upset; she appears emaciated and tired while coming in the bar, where there are FEW CUSTOMERS inside. She talks to a YOUNG BARTENDER.

 VICKY

 Bring me a *monaco*[1] , please.

 YOUNG BARTENDER

 Right away, ma'am.

As the BARTENDER walks away VICKY leans herself against the counter and looks around. In a corner she notices THE SMUGGLER staring at her. VICKY see that he is really a handsome man and in spite of her tiredness she's looking at him with a certain desire; then immediately she turns her head away so as not to give him too much confidence. The smiling SMUGGLER approaches but his smile is mischievous.

[1] Monaco is a typical French drink.

SMUGGLER

(*to VICKY*)

You seem tired, dear.

VICKY

(*snapping with apparent annoyance while actually she feels attracted by him*)

Who the fuck are you, huh?

SMUGGLER

You should give yourself a break.

VICKY

Look, I'm going to yell.

Meanwhile the YOUNG BARTENDER arrives and serves VICKY the *Monaco* French drink. VICKY sips a little of it.

SMUGGLER

Look, you shouldn't get involved with this hot stuff, you people from TV and Troja-gram. That's potentially very dangerous for you.

VICKY

What do you know? And who are you?

SMUGGLER

My name is Ilvastor.

(*Shaking her hand*)

I deal with the human material transport in liquid fields.

VICKY

Look, speak in understandable language. Or get lost.

SMUGGLER

I was telling you and your colleagues, in few words... If you keep on to grab this fuzzy dick, you shall run remarkable risks.

VICKY

We need money. Recently My TV show has suffered a 40% gap in share. We're losing sponsors... That one could have been a great scoop.

SMUGGLER

A question of survival.

VICKY

Smart guy. And now go to Hell.

SMUGGLER

In time. However, I could give you help.

VICKY

(*with mocking smile*)

Help us? That's silly prank.

SMUGGLER

I'm not joking. I can make you meet Stigmatler and talk to him directly.

VICKY

First you tell me "*Give up 'cause it's dangerous*", and now you tell me you want me to meet him?

SMUGGLER

Well, since you're almost broken the risk is worthy.

VICKY

And what should we risk?

SMUGGLER

Your soul.

VICKY

I told you don't make fun of me.

SMUGGLER

If you don't believe it, why did you come to film a supposed miracle?

VICKY

Question of survival I told you.

SMUGGLER

That ghost town's continuing to whirl in the sky above the shore. Look up there.

VICKY

But we can't *rec* it anyway.

 SMUGGLER

 That's why I'm telling you ...

At that moment TONIA and ETZIUS come in,
they're also want to have a drink. TONIA
watches VICKY as she talks to the SMUGGLER
giving her a questioning look that VICKY
ignores.

 SMUGGLER

I'm telling you, I'm the one who organized the
 landing on this coast. Dirty managing. If you
 promise me your silence, I can arrange a
 meeting with Stigmatler for you and Tonia. I
 know how to get it.

 VICKY

 (*stops sipping his Monaco*)

 Well, what should we do?

SMUGGLER

I can bring him to you for a streaming and TV show. Then you could what you yet have in your mind. You and Tonia will organize a combined worldwide transmission together and persuade him to make a miracle. Live.

VICKY

(*choking her laughter*)

This is the biggest bullshit I've ever heard! Sorry, but I find it really tough.

SMUGGLER

(*expression on his face becomes extremely serious and grave*)

This is my promise. Listen to me and you'll improve your audience in half an hour.

 VICKY

 I don't know, I have to talk about it with my
 boss and also with Tonia.

 SMUGGLER

 Tonia is agree.

 VICKY

 Are you so sure of it? And what would you want
 back?

The SMUGGLER stares at her with an intense and
mischievous smile: the fire of lust can be seen
in his flaming eyes. TONIA and ETZIUS stand in
a corner, and TONIA too is also visibly
interested in the SMUGGLER's beauty.

SCENE 26. EXTERIOR/DAY. ON THE LANDING COASTS

3 POPE MESSENGERS have arrived on the coasts on a private jet and they're astonished to observe the celestial city hovering in the air, full of happy AFRICAN IMMIGRANTS. The messengers are A CARDINAL, A BISHOP and A DEACON. Behind them a HUGE CROWD of curious people coming from everywhere to watch the wonder rotating in the sky; many of them try to take photographs but are disappointed: their cameras fail in recording the miracle. The crowd is monitored by POLICE FORCES.

 BISHOP

 Almighty God!

 CARDINAL

 Never seen anything like that.

 BISHOP

Look the Africans, how happy they are up there!

DEACON

One moment, fellows. We are here to investigate and find Stigmatler to bring him to the Pope. All this could be an optical illusion, or a trick of the Evil One.

CARDINAL

But it is so real, so vivid! Not even the Bible describes such a miracle.

BISHOP

However he created the World and the Universe which is a much greater marvel...

DEACON

(*more and more amazed*)

Dear Brothers, watch that!

THE CROWD OF CURIOUS PEOPLE previously noisy is now starting to become mute. The rotating celestial city stops in a fixed point in the sky, then descends from it a sort of holy transparent staircase that can be opened. A MUSLIM is descending from the ladder, he's wearing a turban and a colorful dress. He is about 50 years old, with a friendly and youthful expression on his face and a thick beard. Having descended the holy ladder, the MUSLIM stops in front of the 3 POPE MESSENGERS.

 MUSLIM

 (he's got a white halo around his head)

 Christian Brothers, do not fear. I come to you
 in peace!

The CARDINAL, the BISHOP and the DEACON, as if they're taken by a supernatural force bow, always remaining dismayed and with their mouths open. They are unable to say a word, overwhelmed by tremor and amazement.

MUSLIM

My name is Kwisatz Haderach. I am here on behalf of the Son of Man. He knows why you came here. And he wants to reassure you!

The 3 POPE MESSENGERS continue to watch him in silence. Like the CROWD OF PEOPLE behind them.

MUSLIM

All this is northe work of the man who wants to mock your faith neither of the devil. Stigmatler is the Messiah, the Only Begotten Son, who returned to Earth for God's will. Only at the end the meaning of this plan will be revealed to humankind. So you, my Dear friends, you will have to pay close attention!

The 3 PRELATES are listening to him as if they were the Three Wise Men.

MUSLIM

(*continuing*)

In fact, there are evil forces that wish to lead the world and make you believe that Stigmatler is an impostor and his miracles and wonders are fake. They conspire in the darkness to avoid the divine plan being realized. You must stop them till you have time!

CARDINAL

Oh my Gosh ... Muslim Brother, you have to give us some more precise information ... Who are these people plotting in the shadows?

MUSLIM

(*quoting the Apocalypse*)

"And the fifth angel blew his trumpet, and I saw a star fallen from heaven to earth, and he was given the key to the shaft of the bottomless pit. He opened the shaft of the bottomless pit, and from the shaft rose smoke like the smoke of a great furnace, and the sun and the air were darkened with the smoke from the shaft.

MUSLIM

(*continued*)

Then from the smoke came locusts on the earth, and they were given power like the power of scorpions of the earth. (…) They have as king over them the angel of the bottomless pit. His name in Hebrew is Abaddon, and in Greek he is called Apollyon."

DEACON

???

MUSLIM

(*climbing back up the ladder towards the city*)

Think about these words, Christian Brothers! Goodbye.

BISHOP

No, please wait!

THE MUSLIM disappears on the transparent staircase, which closes back completely and it's irrevocably sealed. The DEACON unconscious falls on the ground.

SCENE 27. INTERIOR/DAY. LUXURY HOTEL. BEDROOM

VICKY, TONIA and the SMUGGLER are having an orgy on a double bed. The SMUGGLER wildly penetrates TONIA while VICKY licks his penis. VICKY in wearing a pink plastic dildo and is sodomizing the SMUGGLER with it. The moans and screams of pleasure of the TWO WOMEN and THE MAN are disturbing. TONIA notices a strange flashing flamingly light in the SMUGGLER's eyes as he possesses her.

SCENE 28. INTERIOR/DAY. LUXURY HOTEL. BATHROOM

The SMUGGLER has just taken a shower. A red and black towel wraps half of his body; his sculpted chest and biceps are magnificent. He lights up a cigarette. VICKY and TONIA slowly are getting dressed; TONIA is sitting on the floor, VICKY on the edge of the tub.

TONIA

What would the plan be?

SMUGGLER

(he smokes on her, and TONIA begins to cough)

I explained it to you. You have to do a TV and streaming live broadcast. It'll be worldwide, and Stigmatler will be the guest star. You will interview him both, then ask him to perform a live miracle.

VICKY

Even if would get him on the air, he'll never do anything like that.

TONIA

Then Vicky and I have been enemies, since the beginning, fighting the audience war each on our own. It's not believable for the public to see us together. They'll suspect it all has been combined.

SMUGGLER

Sure, but this is an exception. And your TV programs are both in dire straits. If you do something together, the spectators could think that you have become friends for a common cause.

VICKY

But the common cause is the audience. Money in few words.

SMUGGLER

Who cares? People certainly won't care about this. People want to see something wonder, they want definitive proof that Stigmatler is a saint or just a trickster.

TONIA

This won't work in my opinion. Listen to me, Vicky, we're going to do some bullshit. Let it go.

SMUGGLER

You're stupid if you don't do it. I can get him to you for TV and web, you have my word of honor. Stigmatler will come.

VICKY

I do not know.

TONIA

What arguments do you have to persuade him to appear on live TV show?

SMUGGLER

I was in the Mafia, before I dealt with immigrants. I know several of Stigmatler's disciples: they're former mafia leaders with whom I have done a lot of business in the past. When they smell the money I offer them, they won't think so long and betray their master.

VICKY

I've heard this before …

TONIA

About two thousand years ago. What's your gain?

SMUGGLER

Enough chatting. Now I have to go. I'll check back in a week, okay?

VICKY and TONIA snorting still look perplexed each other. VICKY lights a cigarette; then they both look up and notice that the SMUGGLER has suddenly disappeared without a trace.

SCENE 29. INTERIOR/DAY. HOSPITAL. EMERGENCY ROOM

STIGMATLER and THE 12 APOSTLES have entered a large modern hospital and are in the emergency room area. Dozens of beds and stretchers piled together: DYING PEOPLE, PEOPLE IN A SEMI-UNCONSCIOUS STATE, screaming or feeling sick. A CHILD WITH COMPLETELY DEFORMED FACE lies in a bed and he's moving fitfully. All around NURSES and NUNS working hard to help. STIGMATLER and the 12 DISCIPLES make their way through this scenery among the amazed medical staff and those few still conscious patients. SOME NUNS astounded look at STIGMATLER. THE PRIMARY of the hospital looks into the emergency room.

PRIMARY

(to the NURSES, making a sign with his arm to STIGMATLER and HIS MEN)

Take them!

HEAD NURSE NUN

No, wait!

There's something like an invisible magnetic halo around STIGMATLER so humans stay distant from him. The 12 APOSTLES faithfully follow him. STIGMATLER and HIS MEN approach the DEFORMED CHILD's bed and make a circle around him.

 A NURSE

Be careful! Don't get too close! We don't know if it's contagious...

STIGMATLER does not react. He looks at his bleeding wrists with cross-shaped stigmata. STIGMATLER opens his hands and covers with the wrists the face of the DEFORMED CHILD, who doesn't protest. A strange light emerges from the blood of the stigmata. The DEFORMED CHILD has now a completely normal face. All the medical staff and other patients stay speechless - including the DISCIPLES, of course.

 PRIMARY
 (*looking at the scene from a corner*)
 My God... That's not possible!

 HEAD NURSE NUN

So you're actually the Messiah!? Are you back?!

STIGMATLER doesn't say a word. He and the 12 APOSTLES again make their way among various sick people. SOME DYING MAN tries to call them.

 DYING

 Help us, please!

 SICK WOMAN

 Let's make a miracle for me!

But STIGMATLER doesn't react. With HIS APOSTLES he walks away leaving the room in the general astonishment.

 PRIMARY
 (to STIGMATLER and the DISCIPLES)
 Wait! Stop. Who are you?

But they have already evaporated.

SCENE 30. INTERIOR/DAY. VATICAN PALACE. SIGNATURE ROOM

The CARDINAL, the BISHOP and the DEACON have returned to their Palace and are talking to the POPE'S SECRETARY about what they saw on the coasts. The POPE'S SECRETARY has an I-Pad on which he's watching the video of Stigmatler's walk on the water, which has now become the most viral video on the web. The 3 MEN are still shocked.

> SECRETARY OF THE POPE
>
> In few words what you saw seems like a marvel described in the Apocalypse.

> CARDINAL
>
> Yes, Mr. Secretary. It was astounding. If you and the Holy Father came to see…

DEACON

That sort of ghost town remains suspended high in the sky and has welcomed all the African immigrants. It works perfectly, even if it doesn't look like a city built by humans …

BISHOP

There are houses, buildings, food and work for everyone. But we can't figure out what material it's made of.

CARDINAL

So a crowd of curious people is always watching down there all day long! They try to talk to the immigrants up there and ask them how they feel …

SECRETARY

There's no camera able to capture that image, I suppose.

 DEACON

 You're right. It's impossible.

 SECRETARY

 (doubtful)

 Um. What I can't understand is why this first
 miracle happened

 (showing the first Stigmatler video on the web)

 and the girl filmed it, but you can't record
 the subsequent ones. In theory no miracle
 should be captured by a camera.

 BISHOP

 However there are photographs of supposed
 ghosts all over the world. And by the way it
 may not be a coincidence.

 CARDINAL

 What do you mean?

BISHOP

The first miracle was probably filmed by an innocent. Those people from TV I have seen there seem corrupted to me - my impression.

DEACON

Do you mean that only those pure of heart can shoot miracles?

SECRETARY

Possibly. I don't know, but I guess that Stigmatler let the first miracle to be filmed like a sort of marketing. The rest is a matter of those that have faith.

CARDINAL

So none of the forthcoming miracles will be recordable.

BISHOP

However, the country he rebuilt in the West Bank was filmed several times, before and after the miracle.

SECRETARY

You precisely said: before and after. Not during the miracle. We can only believe in the good faith of those Israelis witnesses. As it happened in Fatima and Lourdes.

DEACON

But what does the Holy Father say?

SECRETARY

We're going to have another meeting to decide but I guess it would be good for the Holy Father to go there and see what's happening on the landing shore. By now it's quite clear that we are dealing with a supernatural phenomenon. But we must be certain once and for all whether it comes from God or from the Devil.

CARDINAL

The fact that the Messiah come back to Earth Adolf Hitler clothes … Why? This is the reason we must meet him and question him. This could also be a very bad taste joke prepared by someone …

BISHOP

The mild and prodigious Stigmatler could hide in himself the Beast of the Apocalypse...

DEACON

He has only done good things so far!

SECRETARY

Remember, however, that the Antichrist is presented in the Writings as an good-looking man, misunderstood also by the most faithful elected… The only solution is to bring him into Vatican. If he is a demon sooner or later he will react with horror at the sight of the sacred vestments. Now excuse me, I have a meeting.

The SECRETARY goes away to other rooms, leaving the 3 MEN looking each other in an agitated but also hopeful state of mind.

SCENE 31. INTERIOR/NIGHT. COUNTRYSIDE. A SMALL CHURCH.

STIGMATLER and his DISCIPLES entered a small empty church in the countryside. They sit at desks; there is no one but them. STIGMATLER alone approaches the altar and kneels, then prays intensely. Also the DISCIPLES start to pray but some of them occasionally get a little distraction looking at the Master with curiosity. Suddenly they hear the church door is opening. A WOMAN, wrapped in black dress and veil comes in and breathless runs towards STIGMATLER. Doing this she hits a desk's corner and falls down on the floor. The 12 APOSTLES stand up one by one and SPEER approaches the WOMAN and recognizes her.

 SPEER

 (to the WOMAN)

 For Devil's sake! What are you doing here?

 WOMAN

 Take me with you, O Bros!

SPEER

I thought you were in the Manor. Get out! We are wanted.

WOMAN

No! I changed my mind! I am converted. I believe in Stigmatler now!

STIGMATLER gets closer to the WOMAN and recognizes her: she is the lady who sexually tempted him when he went to the luxury manor of the former Mafia leaders now DISCIPLES. STIGMATLER bends over the woman. She is crying.

STIGMATLER

(*to the DISCIPLES*)

Leave her.

(*To the WOMAN*)

What do you want, woman?

WOMAN

(*in tears, looking at him*)

I tried to seduce you, Master, and now I regret it. I want to follow you.

STIGMATLER

Tell me, what's your name?

WOMAN

Gretl. Please, please take me with you.

STIGMATLER

Your sins are forgiven. Why do you want to come with us, woman?

GRETL

Master… You said that whoever is not with you is against you. Well, I'm with you. I'll do everything you want 'cause I want to live, not to die.

SPEER

Master, she's a liar and a whore, I'm sure of it, I have known her for years. Don't believe her words.

GRETL

(to STIGMATLER)

I had a dream. An angel appeared to me and told me that I had to search for you, and at the end I would find you. He also showed me a large furnace. I don't know what it means, but I felt I had to obey.

STIGMATLER

(to GRETL)

All right, woman, may your wish be granted. I see that your heart is sincere.

(to SPEER)

And you, get away from me, Satan.

SPEER

(*humiliated, in sorrow*)

I submit to your will, Master. I really hope Gretl doesn't get us into trouble.

GRETL

(*to STIGMATLER*)

Thank you My Lord. Today is the happiest day of my life, because now I am no longer a servant of Evil.

STIGMATLER helps GRETL to stand up. Then all of them exit from the church.

SCENE 32. INTERIOR/DAY. PALACE OF POWER. LOUNGE AREA

A great celebration is taking place in the halls of the Palace of Power. POLITICIANS, SENATORS, HIGH PRELATES, MOVIE AND TV AND WEB STARS, BANKERS and RICH FINANCIERS are participating. There are BEAUTIFUL WOMEN and WAITERS that serving fine meals on silver dishes; all around furniture and decorations of the highest value. There will be around 200 people. In a corner of the hall on a stage there's A YOUNG RUSSIAN SINGER singing the song *El Mar Mas Grande Que Hay*. At the end of the performance SOME PEOPLE clap the hands. Then another background music starts while everyone is having fun.

SCENE 33. EXTERIOR/DAY. PALACE OF THE POWER. GARDEN

A sumptuous eighteenth-century garden is encircling the Palace of the Power. STIGMATLER and HIS APOSTLES are arriving in front of the Palace. GRETL, with his head half veiled, is together with them. TWO GUARDIANS stand in front of the entrance locking their way.

> FIRST GUARDIAN
> (*to STIGMATLER and HIS FELLOWS*)
> Stop. Who are you?
>
> STIGMATLER
> Let us in.
>
> FIRST GUARDIAN
> You have to show us the invitation.

STIGMATLER looks significantly at GRETL. However she's in panic.

 GRETL

 Why are you looking at me Master?

 STIGMATLER

 Uncover your head, Woman.

GRETL obeys. She slowly removes the veil which wraps her hair and a white letter falls to the ground - she didn't know she owned. THE DISCIPLES and GRETL amazed observe the scene. EICHMANN hurries to pick up the letter and hands it to the SECOND GUARDIAN who opens it suspiciously.

 SECOND GUARDIAN

 (*opening the letter and looking at it, then
 turning to the FIRST GUARDIAN*)
 It seems to me that they are regular.

FIRST GUARDIAN
(*looking perplexed at STIGMATLER and HIS FOLKS*)
Um... You can pass.

SCENE 34. INTERIOR/DAY. PALACE OF POWER. LOUNGE AREA

The party is running in the wildest joy. The background music is bumping. SMALL GROUPS OF PEOPLE scattered here and there eat and drink and talk about the fate of the world. STIGMATLER and HIS DISCIPLES with GRETL come into the room. MANY GUESTS, MEN AND WOMEN, as well as THE SERVERS start to look at them in amazement. STIGMATLER makes his way to the central table - a large table filled with all sorts of foods. A POLITICIAN (probably a PARTY SECRETARY) named ASS-INGER approaches STIGMATLER.

ASSINGER

Please Gentlemen, welcome. My name is Assinger, general secretary of the PP, the Opposition Party which has its base in Absurdistan. Who sends you?

STIGMATLER doesn't answer. The expression on his face is extremely serious. Meanwhile the people's chattering all around is progressively becoming mute.

STIGMATLER followed by the DISCIPLES has approached the large table, and everyone expects him to want to take something to eat. But STIGMATLER - helped by 6 DISCIPLES - with a fast movement shows his small cross-shaped stigmata from which an emerging ray of light overturns the table on the ground breaking porcelain plates and crystal glasses with a bombastic crash. The carpets and the floor are smeared with all types of crashed meals in the embarrassment and the dismay of THE PARTICIPANTS at the party.

STIGMATLER

(to the GUESTS)

You Pharisees of Power, woe to you! You're pretending to oppose each other in the media circus but actually you agree on the division of resources! You who pretend to be righteous while instead be wicked! With your facade policy you claim to help the weakest but actually you only increase your welfare!

STIGMATLER

(*continuing*)

You pretend to condemn rape culture and in the meantime rape the culture! I warn you: bad things come to those in all good time …

ASSINGER

(*in the general silence*)

Really, Gentlemen, I think you're in the wrong party. Please go away and put an end to this masquerade. You have already caused enough damage and you'll have to fix every single thing.

ONE GUEST

Wait! He's Stigmatler! Everyone is talking about him on social media! He makes fake miracles! An asshole pretending to be the Messiah!

ANOTHER GUEST

Yes, I heard about it too… What a joke! This clown goes around the world dressed as Hitler and claims to be Christ! Do you think is it funny this insane humor???

GRETL

(*to STIGMATLER, worried*)

Please Master, let's go! Why all this?

STIGMATLER

I am the Son of Man, and I have come to bring the Sword, not Peace. I have come to divide father from son and mother from daughter. Whoever lives and believes in me will never die; but woe to those who use Power to appear good, and secretly only work to fatten their own interests. It would be better for them if they had never been born!

ASSINGER

(to STIGMATLER and HIS DISCIPLES)

Gentlemen, I ask you for the last time: get out of here forever! I don't know who you are, but you won't get away with it. Our surveillance cameras…

At that moment the GUARDIANS burst in and they both take up their rifles pointing them towards STIGMATLER and HIS FELLOWS.

FIRST GUARDIAN

What's all that noise?

ASSINGER

You're the ones letting them in. Why?

SECOND GUARD

They had the invitation!

STIGMATLER

(*to THE GUESTS*)

Dear sisters and brothers I beg you: believe me. Am warning you all that are in this room, for I see that the World, the Flesh and the Devil already have you firmly in their claws. You hold the fate of this planet in your hands; you manage media and virtual communication and keep everyone under control, and few people know it. Well, you're using these tools according to the will of Darkness. Pray and convert yourselves before it is too late!

A PRELATE

This unlucky guy is pretending to quote the Writings by heart, profaning them with his Carnival costume!

ASSINGER

(*to STIGMATLER*)

If you continue with this horrible pantomime, I will be forced to arrest you.

ASSINGER approaches TO A GROUP OF MEN (about FIVE COPS) crammed into a corner. The LEADER of them is identical in his look to ILVASTOR, the SMUGGLER, even if he's got now a policeman's uniform. So ILVASTOR followed by 4 of them heads towards STIGMATLER and takes him by his arms.

 ASSINGER

 (to ILVASTOR)

Inspector *Storalvi* , I ask you please to take this pathetic idiot and his god-damned folks to the nearest police station.

 ILVASTOR/STORALVI

 Mirabile Dictu, Mr Assinger.

THE FOUR COPS immobilize STIGMATLER in the general dismay and ILVASTOR handcuffs him looking at him with a mischievous glance. STIGMATLER doesn't seem to understand.

 GRETL

 Master!

 ASSINGER

 (*to the GUARDIANS*)

You two idiots, clear the room of this bunch of
 wretched!

But the frightened DISCIPLES that is EICHMANN,
SPEER, PRIEBKE, GOERING, GOEBBELS, SCHRECK,
HIMMLER and ALL THE OTHERS have already run
away. GRETL is the only one crying loudly and
tries to follow STIGMATLER, but THE POLICEMEN
hold her back hitting the girl with a truncheon
and letting her fall to the ground. In the
great general confusion STIGMATLER is led out
of the Palace.

SCENE 35. EXTERIOR/DAY. PALACE OF POWER. GARDEN

THE COPS are leading STIGMATLER out of the Palace, accompanied by the TWO GUARDIANS. There is already a police car in front of the entrance of the garden. STIGMATLER is pushed inside it.

SCENE 36. INTERIOR/DAY. POLICE CAR

ILVASTOR/STORALVI sits behind the wheel and the handcuffed STIGMATLER sits in the back of the car, with TWO COPS near him. ILVASTOR/STORALVI with his usual Luciferian facial expression turns towards STIGMATLER who doesn't say a word.

 ILVASTOR/STORALVI
 That'll be the good time you won't do any
 foolish things. So you have nothing to say
 about it?

 STIGMATLER
 You say it.

 ILVASTOR/STORALVI
 Come on, we'll have fun together.

Once the engine is turned on the car shifts into gear and starts skidding away. MANY GUESTS have scattered around the garden and STIGMATLER watches them from the window as the car drives away. No trace of his Disciples.

SCENE 37. EXTERIOR/NIGHT. HIGH MOUNTAIN LANDSCAPE.

Majestic mountain landscape. It could be the Alps or the Rhine Massif. The 12 APOSTLES that run away from the general Palace of Power chaos, took refuge in a former disused bunker of the Second World War located in these mountains. They keep their mafia clothes and looks. Cold and exhausted because of the frozen weather they took refuge in the bunker. ONE OF THEM has an I-PAD with a not stable connection but through it they manage to keep themselves informed about what's happening in the world. HIMMLER, GOEBBELS, GÖERING, HESS, BORMANN, ROSENBERG, RIBBENTROP, SPEER, EICHMANN, AXMANN, PRIEBKE, SCHRECK are now all gathered together again. Actually they have regrets and are concerned that they did not prevent STIGMATLER's arrest.

SCENE 38. INTERIOR/NIGHT. HIGH MOUNTAINS. FORMER BUNKER

Crammed into a corner of the cold underground tunnel of the former bunker the 12 DISCIPLES are sitting crowded against the wall. TWO OR THREE OF THEM are walking nervous back and forth. HIMMLER occasionally consults web news to see if there are any updates on STIGMATLER's arrest.

> HIMMLER
>
> The connection is not stable … I can't understand if they're yet talking about the Master's capture.

> GOERING
>
> We abandoned him. God will never forgive us.

> EICHMANN
>
> And what do you know about the divine plans?

GOERING

What do you mean?

EICHMANN

Perhaps all this is part of a plan of the Providence.

SPEER

What nonsense.

ROSENBERG

He might be right. Remember Brothers that even two thousand years ago he was taken into prison and then crucified. But that was God's plan for the salvation of humankind.

GOERING

You're wrong. Christ was murdered because he was dangerous to the Roman Empire. Then God transformed the cross into a victory, thanks to his resurrection.

HIMMLER

Enough is enough, Brothers. There's no reason for getting into theological disputes right now. We've got more important things to think about.

SCHRECK

How will we find the Master again? And if we don't find him, what will we do?

HIMMLER

We can do nothing but wait for the events' course.

PRIEBKE

But we can't sit here doing nothing! We have to go look for him!

GOERING

No, Brothers. It may be dangerous …

There's a lot of shouting, everyone is ready to rule his way and there is a lot of confusion. At a certain point they hear some noises with footsteps and screams coming from outside.

EICHMANN

Shut up! Someone's coming.

PRIEBKE

Maybe *They* found us!

ROSENBERG

I knew we shouldn't have gone to the Palace! They have sentinels everywhere! Now they're coming for kill us!

SPEER

What do you say, traitors! We too must be ready to die for the cross, like our predecessors. Someone go and see!

 GOERING

 I'm going!

 PRIEBKE

 I come with you!

GOERING and EICHMANN head towards the entrance
leading to the underground.

SCENE 39. EXTERIOR/NIGHT. FORMER BUNKER ENTRANCE.

PRIEBKE and GOERING look out over the entrance of the former bunker. A figure completely hooded and wrapped in a dark dress is coming towards them. The dress clearly has some Vatican figures and signs drawn on it. The FIGURE moves clumsily, unable to see the path due to the darkness and stumbles.

GOERING

(*suspicious*)

He looks like a pope messenger.

PRIEBKE

How did he ever manage to reach us?

GOERING

Of course, there were Vatican delegates at that party. Maybe they've got an offer to us...

PRIEBKE

Never! We will never compromise!

GOERING

Shut up, Priebke! Let's hope he's not armed. If he tries to hit us, we'll knock him down in two.

PRIEBKE

Actually we shouldn't react to Evil by using the evil …

Meanwhile the STRANGE FIGURE comes closer and closer to them and recognizes them. She heard their voices.

GOERING

(*to the STRANGE FIGURE*)

Stopped! Who the hell are you?

The FIGURE laboriously removes his hood. It's GRETL.

 PRIEBKE

 Gretl! How did you find us?

 GRETL

 (*exhausted, stuttering*)

 I was guided by the Archangel!

 GOERING

 Come inside with us. You need a rest!

GRETL obeys and approaches the entrance, but falls tired and unconscious into GOERING's arms.

GOERING

(*holding her, talking to PRIEBKE*)

Priebke, help me lift her! Let's take her to the others!

SCENE 40. INTERIOR/NIGHT. **MAXIMUM SECURITY PRISON. INTERROGATION ROOM**

STIGMATLER was led to the prison by ILVASTOR, now in the appearance of INSPECTOR STORALVI, after being a SMUGGLER. STIGMATLER is led onto a dark room to be interrogated by STORALVI and ONE OF HIS ASSISTANTS. STIGMATLER sits on a chair without saying a word, under the demonic supervision of STORALVI and the more impartial one of his ASSISTANT.

 ILVASTOR/STORALVI

So, Stigmatler. That's the way they call you. Why?

STIGMATLER mute reluctantly shows the small perpetually bleeding stigmata on his wrists.

 ILVASTOR/STORALVI

 (*commenting on the stigmata*)

And those? You did it by yourself, tell the truth.

STIGMATLER

(*quiet*)

My Father, who is in heaven and sees into the heart and soul of Man, gave them to me as a recognition's mark.

ASSISTANT

(*sarcastically looking at STORALVI*)

We need a neurologist here.

(*then to STIGMATLER*)

Do you want to know what we think of you?

STIGMATLER closes his wrists and puts his hands in his pockets. He put the head down.

ILVASTOR/STORALVI

...That you are more dangerous than neo-Nazis. You and those 12 inept followers have thrown the world into chaos. Tell me, was this mess so necessary?

STIGMATLER

My Father decided to send me back to Earth to teach humanity to recognize Good in the guise of Evil.

ASSISTANT

Sure. Why not?

(*to ILVASTOR/STORALVI*)

Boss, how many bullshits do we have to hear. Why don't we lock him up right away?

ILVASTOR/STORALVI

No, wait. He would like to say that the Good often presents itself in unpleasant shapes in our lives, while Evil takes on a seductive appearance to deceive and blackmail us. Well, he re-invented the wheel!

ILVASTOR/STORALVI and HIS ASSISTANT start laughing out loud. But their loud laughter is interrupted by STIGMATLER.

STIGMATLER

And you, who do you say I am?

ASSISTANT

A madman, an impostor. You see the Vatican is extremely worry about the mess you made, including your supermarket miracles... The flying cities, the multiplied breads and fishes, that village rebuilt in 3 days, the worst mafia bosses now "converted" … Who pays you to make people believe these fairy tales? What kind of advertising would that be?

ILVASTOR/STORALVI

(to STIGMATLER)

It seems that the Holy Father wishes to meet you. But firstly you have to tell us the whole truth about who sends you and who finances you. The Ashkenazim? Or the Zionists, or the Sephardim? Hamas, or Al Qaeda?

STIGMATLER

I already told you. I am the One who comes in the name of the Lord.

ASSISTANT

(*to STORALVI*)

Her doesn't surrender! He insists on taking the piss out of us! Boss, let's throw him in a cell right away. He'll lose the desire to make fun of us after a night of isolation, you'll see!

ILVASTOR/STORALVI

(*grinning*)

It seems we have no other choice. And if that's not enough, I will ask for Special Treatment for him.

(*to the ASSISTANT*)

Leave us alone for a moment.

THE ASSISTANT leaves the office slamming the door.

 STIGMATLER

I don't know why but … I'm sure I met you before somehow.

 ILVASTOR/STORALVI

 (*always glancing at him*)

Haven't figured out who I am yet? Ain't you remember in the desert? And some time ago, on that beach among immigrants? I told you that we would see each other again.

SCENE 40B. EXTERIOR/DAY. LONDON. TRAFALGAR SQUARE

The STIGMATLER Mania has meanwhile spread to various parts of the world. In Trafalgar Square, London, we see 3 ACTORS DOUBLES of STIGMATLER dressed and made up identical to the dictator on a show in the square performing fake miracles with plastic loaves and fishes used as magic tricks, surrounded by AMUSED CHILDREN AND TEENAGERS WITH THEIR FAMILIES. SOME OF THEM stand on a small podium and preach Love for everyone. People claps their hands filming the show with their cell phones and observe them laughing.

SCENE 40C. EXTERIOR / DAY. LOS ANGELES. RODEO DRIVE.

Same scene as the previous one, with THREE OTHER AMERICAN GUYS looking like Stigmatler that preach in front of some shops on Rodeo Drive.

SCENE 40D. EXTERIOR / DAY. NAIROBI. ALL SAINTS CATHEDRAL

TWO OTHER MEN totally similar (make-up ad dresses) to Stigmatler are pretending to evangelize people in African language in front of one of the most important religious buildings in the capital of Kenya. SOME PASSERS-BY amused throw coins at them.

SCENE 40E. INTERIOR/EXTERIOR - NIGHT. MOUNTAIN LANDSCAPE AND NEONAZIST BUNKER

Meanwhile the neo-Nazis also took refuge in an old former bunker not far from the one where Stigmatler's followers are. The Neo-Nazis have just finished an assembly and 3 or 4 of them, while sipping a beer, look out at the entrance from the underground. A SKINHEAD notices a strange phenomenon in the starry sky. In fact, a swastika-shaped comet appears. So Neo-Nazis are dismayed.

 A SKINHEAD

 (*to the other FELLOWS*)

 Watch out there!

Inside the swastika-shaped comet there's the mischievous face of A DEMON but the NEONAZIs don't recognize it. It seems that the comet is inviting them to follow.

 AN ELDERLY NAZI

 Maybe it's a sign! Maybe we should follow it!

 SKINHEAD

 We must tell to Amoth!

 ANOTHER NEONAZI

 Perhaps that comet will lead us to the Führer
 again!

 NAZI ELDER

 It's possible. Norse Gods remembered us!

While the DEMON's FACE grins inside the
fluorescent swastika-shaped comet suspended in
the sky the 4 NAZIs run below to warn their
leader.

SCENE 41. INTERIOR/DAY. MAXIMUM SECURITY PRISON. IN FRONT OF THE CELL.

Before being locked up STIGMATLER is put in front of his isolation and he's brutally beaten by FOUR INMATES specifically chosen by ILVASTOR/STORALVI. There are FOUR WIRY, TATTOOED, MUSCULAR INMATES - real tough guys. STIGMATLER doesn't resist and accepts the beatings with stoicism. ILVASTOR/STORALVI watches the scene impassively and after all enjoying it. Then he goes away to a corner of the corridor and ANOTHER MYSTERIOUS GUY gives him a white box in the shape of a swastika. ILVASTOR/STORALVI opens it and takes out a crown of thorns identical the Jesus Christ's one. He places the crown of thorns on STIGMATLER's head while the INMATES laugh among themselves.

<p style="text-align:center;">ILVASTOR/STORALVI</p>

<p style="text-align:center;">(to STIGMATLER)</p>
<p style="text-align:center;">Hey, now you really look like Jesus!</p>

<p style="text-align:center;">(to the INMATES)</p>

<p style="text-align:center;">Lock him up!</p>

THE FOUR INMATES immediately lift up STIGMATLER from the ground like if he's a heavy bag, then open the cell and place him inside on a cot. So they close the door with bars and still giggling they walk away together with ILVASTOR/STORALVI.

SCENE 42. INTERIOR/NIGHT. MAXIMUM SECURITY PRISON. PRISON CELL.

STIGMATLER melancholy places his bleeding head on the bed without taking off his clothes or removing his crown of thorns. Moonlight filters through the window. STIGMATLER looking at the moon through the window gets up sorrowfully and talks to God.

STIGMATLER

(*praying and imploring God*)

My Father... Have I done everything you wanted so far, or have I made a mistake? If you can, take this bitter cup away from me... But your will be done.

(*sobs lightly*)

But please, Heavenly Father, you who know everything … send a sign for your poor lost son. Whatever it is you will decide, Father: send a sign, I beg you, to your Only Son. Even if it were the Golgotha again... But don't abandon me.

SCENE 43. INTERIOR/DAY. MAXIMUM SECURITY PRISON. HALL OF THE COMMISSIONER.

STORALVI/ILVASTOR sits on a strange stool reading the newspaper while HIS ASSISTANT drinks hot coffee and plays with the apps on his cell phone. The doorbell rings.

ASSISTANT

(*interrupting the action*)

Who will be, Chief?

STORALVI/ILVASTOR

Vatican delegates. They come to discuss that Stigmatler case. Let them in.

THE ASSISTANT goes to the door and opens it. The DEACON, the BISHOP and the CARDINAL enter the room.

STORALVI/ILVASTOR

Dears! Welcome.

CARDINAL

Thank you for contacting us so fast, Inspector Storalvi. This is a good opportunity to finally evaluate the situation.

STORALVI/ILVASTOR

We caught him just right for you. The prisoner is in his cell now... If you want to follow me...

STORALVI/ILVASTOR followed by the DEACON, the BISHOP and the CARDINAL leaves the room.

SCENE 44. INTERIOR/DAY. MAXIMUM SECURITY PRISON. CORRIDOR AND STIGMATLER'S CELL.

ILVASTOR/STORALVI together with the CARDINAL, the BISHOP and the DEACON arrive in front of the Messiah's prison cell. STIGMATLER is painfully curled up on his bed with his head still bleeding and he has not taken off his crown of thorns. Awakened by the sounds of the bolt turning in the lock STIGMATLER gets up. THE FOUR MEN come into the cell.

DEACON

(about STIGMATLER's look)

Why that crown of thorns on his head?

STORALVI/ILVASTOR

It probably would be a joke involving four inmates. By the way it's a fake crown …

DEACON

Um. It looks like it's really bleeding.

BISHOP

Well, let's get to the point...

STORALVI/ILVASTOR

(*to STIGMATLER*)

Show these gentlemen what you have on your wrists.

STIGMATLER, head down, stretches out his arms towards the THREE PRELATES and slowly opens the fists he kept closed. So he shows them the two small bleeding cross-shaped stigmata on his wrists.

CARDINAL

(*to STORALVI/ILVASTOR*)

How did he get them?

STORALVI/ILVASTOR

He claims to be the Messiah telling God would have inflicted those on him as a sign of recognition for humankind. It is through those bleeding stigmata he makes all the miracles.

CARDINAL

(*to STIGMATLER*)

Come on, talk to us. Who you really are? Some say that you are the Christ, the Son of the Lord who returned to Earth to teach humanity to forgive Absolute Evil.

STIGMATLER

You say it.

BISHOP

I don't think he wants to cooperate.

CARDINAL

However, we should take a sample of that blood and have it examined by our experts. We need to understand what kind of blood is.

STORALVI/ILVASTOR

Like weeping Virgin Mary statues?

CARDINAL

Approximately. We need authorization to do the clinical exam.

DEACON

I would bring him to the Pope immediately. He can evaluate this case better than any doctor.

STORALVI/ILVASTOR

I don't want to contradict you, father, but this is a dangerous element. If we take him out of here he might try to escape... We are also looking for his so-called apostles.

BISHOP

I would mean to authorize the clinical examination in prison, then, depending on the verdict of our commission, we will decide whether to lead to the Holy Father.

STORALVI/ILVASTOR

You already have our authorization for blood tests. You can do them tomorrow.

DEACON

But the prisoner must agree.

STIGMATLER

I submit myself to the will of My Father. But be careful: if you do not believe in me, you 'll find yourself in great danger.

STORALVI/ILVASTOR

(to STIGMATLER)

Why don't you perform a miracle here, now, for these prelates so kind to come visit you?

STIGMATLER doesn't answer.

STORALVI/ILVASTOR

(*to the THREE PRELATES*)

You see? He's unable to perform any miracles. All a sham. I just wonder who is behind all this...

CARDINAL

After we have heard the Pope's opinion... only then will we decide what to do.

BISHOP

The deacon will return here tomorrow morning accompanied by our team of doctors with all their paraphernalia.

STORALVI/ILVASTOR

That's fine. But don't fool yourself - those stigmata have nothing prodigious according to my opinion. This impostor must be kept in prison and then we have to catch also him those 12 wretched

DEACON

Providence will help us.

SCENE 45. EXTERIOR-INTERIOR/DAY. HIGH MOUNTAINS. FORMER BUNKER

An enormous fog is descending on the great mountain and on its landscapes. The banks of fog also cover the door of the former bunker. Cold and worried THE DISCIPLES are huddled against the wall of a corridor half lit by the dim rays of the sun.

ROSENBERG

I'm hungry, I'm cold... I cannot stand it anymore.

GOERING

Gretl went in search of food together with Priebke… May God be with them.

GOEBBELS

Yes, may God be with them. And with us.

SPEER

I've been out for two hours. The fog banks are rising, and furthermore there's no web signal here...

GOERING

Maybe it's a mistake to stand here. Maybe we need to go and free our Master.

GOEBBELS

But we don't even have any idea where he is...

SPEER

Mass media don't get any news about him. They managed to cover up everything, you know … Those damned ones.

ROSENBERG

Ugh, I'm hungry and cold, and you're chatting...

GOERING

Have Faith, Rosenberg. Gretl and Priebke will definitely be back with something to eat.

HIMMLER

Yes, we must have faith. God certainly didn't put us here by chance. I propose a prayer vigil.

GOEBBELS

Okay Brothers, let us pray. God has not abandoned us. Let's pray and don't be discouraged by adversities.

SCENE 46. INTERIOR/NIGHT. MAXIMUM SECURITY PRISON. STIGMATLER'S CELL AND CORRIDOR.

Sitting alone in his cell STIGMATLER is trying to sleep when he hears noises coming from EXTERIOR. He gets up and looks out the window: A GROUP OF STRANGE GUYS completely black-dressed and bundled up with hoods have infiltrated the prison and they are walking in silence in the courtyard. There are TWELVE OF THEM. Then they disappear. STIGMATLER returns to put his head back on the pillow, but he hears something like the sound of bolts in the distance and a second sound of footsteps approaching his cell. STIGMATLER gets up again and approaches the cell bars looking out: the 12 MUFFLED AND BLACK-CLOTHED GUYS are silently approaching his cell.

 STIGMATLER

 Here's the sign... My dear disciples!

 AN INDIVIDUAL

Shut up, old man! Or they will hear you. We had a hard time disabling the alarms and evading the surveillance.

ANOTHER INDIVIDUAL

(*with pliers he begins to break the lock of the cell*)

But if you are the son of God, why didn't you free yourself?

STIGMATLER

Get away from me, Satan! Always the same, Goering…

In an instant the TWELVE GUYS are inside. They surround STIGMATLER. ONE OF THEM takes out a sort of baseball bat from his costume and hits STIGMATLER very hard on the head. Still smiling he falls to the ground

A HOODED INDIVIDUAL

Well done. So at least he remains quiet. Now help me lift him up and get out of here.

SIX OF THEM surround STIGMATLER and lift him up. Then they carry him out of the cell silently bundling him in a large purple bag.

THREE MEN stand in front of the procession and THREE OTHERS at the end of it. A WATCHMAN on duty who had been hit and was lying examined on the corridor's floor is becoming conscious. He immediately notices the strange procession that is carrying this huge and human-shaped sack out of the prison. He stands up and steps in front of them with difficulty trying to stop them.

 NIGHT GUARD
 Hey, you! Who are you? What the hell are you
 doing, fuckers!

ONE OF THE THREE GUYS at the head of the line very quickly pulls out a silencer gun and hits him on the head. A hole of blood opens on the forehead of the WATCHMAN who falls dead. The procession resumes in complete tranquility taking STIGMATLER out of the corridor and the prison.

SCENE 47. EXTERIOR/INTERIOR - DAY. MOUNTAIN LANDSCAPE. NEONAZIS FORMER BUNKER

A mountain landscape similar in some views to that one in which true disciples took refuge. It must have been an old bunker from the Second World War. Inside the bunker STIGMATLER's examined body has been extracted from the purple bag and rests on a sheet in a corner. The TWELVE HOODED GUYS are taking off their costumes that avoided us to seeing their faces. ONE OF THEM approaches STIGMATLER and begins to slap heavily him in the face. STIGMATLER slowly wakes up.

 AN INDIVIDUAL
 (slapping him)
 Oh, old man! Wake up! Jesus Fucking Christ.

STIGMATLER opens his eyes and when he finally becomes aware of the spectacle in front of him the expression on his face becomes disconsolate: there are TWELVE NAZISKINS, the neo-Nazis that had celebrated him in the countryside near POTSDAM believing him to be the reincarnation of the Führer. STIGMATLER is struggling in panic.

STIGMATLER

My God… There's a misunderstanding. I'm not who you think I am, I told you!

But THE TWELVE NAZIs have already bowed and raised their hands and arms to give the Hitler salute.

THE TWELVE NAZIS

(*chorus*)

Heil, Hitler!

STIGMATLER is shocked and disappointed.

ONE OF THE NAZIS

Now we'll take you downstairs where the big assembly runs! We want you to show us the Way to restore Arianism and conquer the planet!

STIGMATLER in despair falls back to the ground putting his hands in his hair and closing his eyes.

 NEW NAZI CHOIR

 Heil, Hitler!

 ANOTHER OF THE NAZIs

 We all work for the Führer!

 ANOTHER NAZI

The Führer has returned from beyond to lead us! We thank the comet that drove us this far!

The NAZIs surround him and lift him up, then lead him towards an underground tunnel.

SCENE 48. INTERIOR / DAY. BUNKER. UNDERGROUND AND BASEMENT TUNNEL.

The NAZIs drag STIGMATLER through the dark tunnel which leads to another larger and this time well-lit room. STIGMATLER offers no resistance; he's supine to the will of Heaven which has led him towards this new test. In this large illuminated room a series of chairs arranged in a cirle and a desk with a microphone placed on the top of it. MANY NEONAZISTS are sitting on the chairs; they're all males and of all ages. We have young people with colored mohawks and studs and older men with an appearance that is sometimes particular and sometimes more ordinary. They all wear the red-white swastika band wrapped around their left arm. A BLACK GUY comes up to the desk, a man of about 55 years old with perfect Nazi uniform. He has a mustache and a sly smile. STIGMATLER is placed by the NAZIs in a dark corner not far from the desk and he's admired by all those present. Then the TWELVE NAZIS also take their seats and the BLACK NAZI (I will call him AMOTH) takes the floor.

 AMOTH

 (to THE OTHERS)

 Brothers, I announce to you that this is a
 great day for us. We saved our Führer from the
 clutches of Christians and communists and
 finally brought him back to the most
 comfortable environment for him. This is a
 great moment. Adolf Hitler is among us again!

AMOTH indicates the resigned STIGMATLER who
remains crammed into his corner. Everyone has
been watching him obsessively since he entered.

 AMOTH

 Brothers! Someone among the Jewish Powers has
 decided to pass off this man as the New
 Messiah. Christ would return to Earth in Adolf
 Hitler's look challenging humanity to recognize
 him in these new - and for us truly holy -
 guises.

AMOTH

(*continuing*)

But it's all a deception! Dear brothers, do not believe in this ridiculousness at all. We know very well that Christ was indeed never resurrected and … he probably never even existed!

A unanimous chorus of applause and shouts rises up as a sign of approval.

AMOTH

The only god, the only man, for us, Aryan friends, that is capable of resurrection is: the Führer! Therefore we believe that the Norse gods wanted to give us a sign by sending back to Earth the one who had started but unfortunately not completed the extermination of the Jewish Power on this Earth! Long live the Führer!

(*pointing with his whole body to STIGMATLER*)

Heil, Hitler! Welcome back to us, Mein Führer!

Applause and shouts of encouragement. Enthusiastic shouts and whistles. STIGMATLER is pushed through the small crowd near the desk and AMOTH invites him to the podium. STIGMATLER resignedly approaches the microphone and takes the floor.

STIGMATLER

(*to the audience*)

Dear Brothers, I am not who you think. I am actually the Messiah, the Anointed of the Lord, and I have returned to Earth to repeat you all have to recognize the Good also in Evil clothing.

The small crowd falls silent and a few snorts begin to be heard.

STIGMATLER

Good God often hides himself under unpleasant guises and even the Wicked knows how to disguise itself as good, My dear ones.

AN ELDERLY NAZI

He reinvented the wheel!

A YOUNG NEONAZIST

Show us the way, instead! Let's arm ourselves and overthrow the Jewish Power that still controls the entire world!

ANOTHER NAZI

And planetary finance!

STIGMATLER

...

AN ELDERLY NAZI

If you really are the Messiah, let's work a miracle! Make us all millionaires!

There are some laughs.

 AMOTH

 (*takes the microphone*)

Brothers and fellows, please! Just a glimpse of
respect, please. The Führer came here facing
prisons and disasters and we welcome him like
barbarians! Shame on you, dicks. The Führer is
tired, he had a bad night, the police will
already be on his trail. We will call a new
conference for the next day. Now let's let him
 rest.

AMOTH accompanies the exhausted STIGMATLER back
to his corner in the general perplexity of the
bystanders that are abandoning their chairs and
gradually retreating to their rooms. Some
surrounding doors lead to other underground
corridors. In few minutes the room is empty:
only SIX of the NEONAZIS that took away
STIGMATLER from prison are left. AMOTH takes
them aside.

 AMOTH

You! Put him to sleep in the Reserved Room, and
make sure he doesn't escape. Someone will watch
 over him during night.

THE NEONAZIs lead STIGMATLER out of the room towards the main underground tunnel.

SCENE 49. INTERIOR NIGHT. SECOND BUNKER. RESERVED ROOM.

STIGMATLER rests in his bed in an isolated room illuminated by the light of some lamps; on the wall there's a large flag with a swastika. Portraits of the real Adolf Hitler hang on the walls everywhere. On the nightstand next to the bed there's one copy of MEIN KAMPF book. STIGMATLER looks at his bleeding wrists with the stigmata and then takes a small rosary with a brown cover from his pocket. So he begins to pray.

SCENE 50. EXTERIOR - NIGHT. NEONAZIS BUNKER. ENTRANCE

At the entrance of the bunker, a NIGHT WATCHMAN walks back and forth and he's armed with a rifle. He hears some footsteps in the distance and notices A STRANGE FIGURE coming to him. He looks like a PUBLIC OFFICIAL. The NIGHT WATCHMAN is alarmed and puts his weapon against the PUBLIC OFFICIAL. He immediately gets up his hands in a sign of surrender continuing to advance the NIGHTT WATCHMAN. The PUBLIC OFFICIAL looks-like points on him a flashlight with an extremely intense and fluorescent - almost blinding - light. The NIGHT WATCHMAN puts his rifle on the ground.

 NIGHT WATCHMAN

Hey! What the hell of light is that?

The PUBLIC OFFICIAL looks-like gets even closer. With his own flashlight he illuminates that grinning expression on his face. (It's ILVASTOR, now in the guise of PUBLIC OFFICIAL). He's holding a briefcase.

PUBLIC OFFICIAL/ILVASTOR

Be quiet. We are old friends.

NIGHT WATCHMAN

Who are you? How did you find us? Who sends you?

PUBLIC OFFICIAL/ILVASTOR

I am a public official. I'm here by will of the Government.

GUARDIAN

Communist police?! Holy shit …

PUBLIC OFFICIAL/ILVASTOR

Keep cool.

(*showing the briefcase*)

We can solve problem as friends. Give me the prisoner and I will bring him back to the Authorities, so I will give you this little gift.

NIGHT WATCHMAN

What does it contain?

PUBLIC OFFICIAL/ILVASTOR

30 coins of silver … Just kidding. I meant, 12 million euros.

NIGHT WATCHMAN

(*laughing*)

My ass. Open the case, body.

The PUBLIC OFFICIAL/ILVASTOR does. The suitcase actually contains several bundles of banknotes of 500 euros. The NIGHT WATCHMAN becomes serious.

NIGHT WATCHMAN

Fake pieces.

PUBLIC OFFICIAL/ILVASTOR

Of course not. Take me to the prisoner, Stigmatler, so that I can bring him back to prison. Money are for you.

NIGHT WATCHMAN

You mean our organization?

PUBLIC OFFICIAL/ILVASTOR

(*tough voice tone*)

Why are you keep on stressing me with this? Now bring me to him. Right away.

NIGHT WATCHMAN

All right, Lord, all right. Let's go there.

SCENE 51. INTERIOR/NIGHT. NEONAZIS BUNKER. TUNNELS AND AMOTH'S ROOM

The NIGHT WATCHMAN followed by ILVASTOR/PUBLIC OFFICIAL make their way along the tunnels leading to underground rooms. Once in front of entrance of Chief Amoth's room the NIGHT WATCHMAN stops.

 NIGHT WATCHMAN

 Please wait for me.

The NIGHT WATCHMAN enters AMOTH's room; he's awake watching pornographic films on I-Pad. AMOTH is alarmed by this unexpected visit and immediately closes the tablet feeling a little ashamed. The NIGHT WATCHMAN enters AMOTH's keeping the little suitcase in in his hand.

 NIGHT WATCHMAN

Forgive me Brother Amoth … there's a very urgent matter we need to talk about.

AMOTH

For Christ's sake. What do you want at this hour? Is the Führer running away?

NIGHT WATCHMAN

No Chief… it is isn't the Führer. There's a man out here. A public official sent by the government authorities … who brought a ransom for the prisoner. They want him back.

(showing the briefcase)

AMOTH

Be careful, Body. This could be the usual communist spy sent by the Jews.

NIGHT WATCHMAN

That's just what I was wondering, Chief. He offers us this money in exchange for bringing Mein Führer back to the authorities.

AMOTH

Um… And they tell us in the middle of the night? We see.

(*He opens the briefcase seeing all the banknotes*)

Jesus Christ …

NIGHT WATCHMAN

12 millions, Chief.

AMOTH

Have you counted them?

NIGHT WATCHMAN

No Chief, but…

AMOTH

Alright. Look, let's take some time. Tell that guy we'll think about it and maybe tomorrow we'll consider what to do. Agree?

 NIGHT WATCHMAN

 Chief, I'm afraid that officer wants him
 immediately…

 AMOTH

 We can do that but he must give us time to
 bring the prisoner back. With this money we're
 going to solve all our problems. He came to
 bring us the money at night, we will bring the
 Führer back at night. That's my deal. Tell him
 so and see.

 GUARDIAN

 AS you desire, Chief.

NIGHT WATCHMAN returns to ILVASTOR/PUBLIC
OFFICER who was waiting for him.

 NIGHT WATCHMAN

Sir, my Chief told me to tell you that some of
 our people will bring back the prisoner
tomorrow night, quietly, without being noticed
 by anyone. He told me to thank you for the
 generous offer.

ILVASTOR/PUBLIC OFFICIAL

Yes, I already know everything body. I heard your conversation.

GUARDIAN

But it's impossible, Sir. The walls here are very thick …

ILVASTOR/PUBLIC OFFICIAL

If you don't bring back the prisoner tomorrow night, you all will be arrested, tell this to AMOTH.

NIGHT WATCHMAN

How do you know Amoth name?

ILVASTOR/PUBLIC OFFICIAL

I'm not kidding folk. We know where you are, and if you do right we'll leave you alone forever and ever. See you tomorrow … night.

 NIGHT WATCHMAN
 I'll show you the exit, Sir.

 ILVASTOR/PUBLIC OFFICIAL
 No need. Good night, and have sweet dreams
 fellow.

ILVASTOR/PUBLIC OFFICER moves away through the
tunnels with his lit dazzling torch. In the
distance he is disappearing in a violent and
lightning-fast blue flame appearing from
nowhere. The displaced NIGHT WATCHMAN is
looking for ILVASTOR/PUBLIC OFFICER'S footsteps
on the ground but there is no longer any trace
of him.

SCENE 52. INTERIOR/DAY. DISCIPLES FORMER BUNKER AND TV STUDIOS.

GOERING, HIMMLER and PRIEBKE together with GRETL watch the preview of VICKY's next broadcast, "WHAT-THE-HELL?!" on the screen of an old I-PAD. VICKY appears on full screen in all her beauty.

 VICKY

Ladies and gentlemen … Um, actually there are also men, of course!

 (*laugh-track*)

As you know, my colleague Tonia and I have always been divided by a brutal professional rivalry... But this time we decided to join our forces for the most sensational TV and online event of all time!

 (*Fake applause*)

Stigmatler, that guy who claims to be the Messiah and makes miracles even if he provocatively shows himself as the most evil man of the 20th century and of all human history … has finally accepted to be the guest star on air this evening!

(Fake applause and laugh-track. The camera shows the studio and we see also frames Tonia with perfect make-up and in a sexy dress)

TONIA

Yep Friends, female and male friends ... this is an unique broadcast with a Hitler-looks-like Messiah who will work live miracles for us in front of the camera thus showing everyone his authentic divine nature! No special effects, Ladies & Gentlemen!

GRETL indignant quits the I-PAD.

GRETL

I can't believe it... Our Master would never do something like that.

GOERING

He is prisoned ... How possible they brought him on TV?

PRIEBKE

Maybe someone decided to free him...

SPEER

Or maybe he changed his mind and made a miracle to become free!

GRETL

But he would never perform a miracle on live TV. You cannot make miracles on command.

HIMMLER

There's something not logical.

GOERING

Nonsense... You feel overwhelm by troubles.

HIMMLER

Then what should we do? Go to the TV studio and try to get him away from there?

GRETL

It's impossible. Restricted environments. They would never let us in.

GOERING

We can't do anything but wait. We'll watch the live broadcast and see what happens. If we are making mistakes, God will send us a sign to bring us back to the right path.

PRIEBKE

I agree. We have to watch him on TV.

SCENE 53. EXTERIOR/NIGHT. HIGH MOUNTAIN LANDSCAPE.

A procession of 14 rigorously hooded NEO-NAZIS (there's AMOTH among them) is leading STIGMATLER towards the prisons again as agreed with Ilvastor. One of them got with him for precaution the strange black briefcase containing the money. They walk pushing on Stigmatler as if he were an animal keeping him handcuffed and dragging him with a rope to make sure he doesn't escape.

 STIGMATLER

Children, I really don't understand you.

 FIRST NAZI

Shut up, Boss. If you are truly the Son of God, why don't you free yourself from this rope?

 STIGMATLER

God reveals to me little by little what I have to do.

SECOND NAZI

Forget it.

(*to the Nazi with suitcase*)

be careful with that stuff and don't wave it too much. We'll be at the jeep soon.

THIRD NAZI

Why do we have to treat him like this? Keep him tied up like a salami or fish? Why bring him back to prison? Wasn't he supposed to lead us to the final battle against the Jews?

FIRST NAZI

That briefcase will guide us to victory not only over the Jews, but over everything. We no longer need him.

They finally arrive in front of a large black jeep parked near a dirty path.

ONE NAZI

(*to the gang*)

Stop. This is the place.

NAZI with the suitcase notices that it is starting to emanate strange lighting sparks.

NAZI WITH SUITCASE

Wait a minute, Folks! There's something wrong.

FIRST NAZI

Shut your mouth idiot. No time for giggles. We must do all the things as soon as possible!

NAZI WITH SUITCASE

Chief… You wanted me to bring the suitcase with me cause you don't trust to leave it in the bunker, but it seems to me that something has changed. It had heavy weight when we left … now it has become light as paper.

ANOTHER NAZI

What the fuck are you saying!? Light as paper?
Is it perhaps empty? You lose the millions
Fucker? On the lawn? Along the way?

NAZI WITH SUITCASE

I don't think so. But we'd better open it for a
moment and check it out.

FIRST NAZI

Leave me alone, I'll open it. Take the Führer
faraway from here for a moment.

ONE OF THE HOODED NAZIs takes STIGMATLER and
still with little regard leads him far away
from the jeep.

SCENE 54. EXTERIOR/NIGHT. HIGH MOUNTAIN LANDSCAPE. NEAR THE JEEP

The 13 left NAZIS take off their hoods one by one and gather around the black briefcase. From it strange incandescent sparks continue to light on all four sides.

> AMOTH
> Of course it's strange. It seems fucking empty.

> AN ELDERLY NAZI
> I knew it! That motherfucker set us up. God damn it!

> AMOTH
> Shut up old man. Let's open it and see what's glittering inside.

ONE OF THE NAZIS approaches with the key and turns it in the lock. They slowly open the suitcase from which an increasingly intense blinding blue-yellow light begins to emerge.

SCENE 55. EXTERIOR/NIGHT. HIGH MOUNTAIN LANDSCAPE.

STIGMATLER and HIS NAZI WATCHER stand far from the jeep in a corner of the mountain nearby some hill. THE NAZI WATCHER has taken off his hood and is smoking a cigarette when they both see an enormous flashing strange light coming from the jeep and hear a terrifying roar like an explosion. The NAZI WATCHER looks alarmed at the jeep watching that blaze of fire rising up in the night. Frightened he throws the cigarette on the ground while STIGMATLER also looks at the scene terrified

 NAZI WATCHER

 Holy Shit!

He runs away like hell presumably returning towards the bunker and leaving handcuffed and cold STIGMATLER alone. STIGMATLER gets down on his knees in the darkness illuminated only by the fire of the distant explosion.

STIGMATLER

(*to God*)

Father you're not abandoning me, don't you?

STIGMATLER remains that way watching the starry sky.

SCENE 56. INTERIOR/NIGHT. TV STUDIOS.

A huge TV theatre. Large scenography with surrealist atmosphere. The audience is full. Remarkable tension in the air. The lights are focused on VICKY and TONIA that are stars-truck in their very sensual evening dresses on the stage. A long applause begins with whistles and shouts. VICKY and TONIA smile and bow to the audience with thanks. In the center of the stage there is a red leather armchair. Among the audience we notice many of the guests that were at the "Palace of Power"; among bystanders we also see an elegantly dressed ILVASTOR sit with sardonic grin on his face. Pompous music plays in the background.

 VICKY

Ladies and gentlemen, thank you for being here tonight. My colleague Tonia and I have come together to present to you a terrific and incredible show which humankind will only have the chance to see once in its entire history.

Another roaring applause, shouts of jubilation.

TONIA

You are so good! Ladies and gentlemen, the first divine miracle is about to take place here via live streaming and TV. The man who is about to appear on this stage has been mostly accused of being a scoundrel, an impostor, or even the Devil himself. But we have witnessed his real miracles and we have faith that in spite of his look he's the Messiah returned to Earth helping us to evolve!

The audience suddenly becomes silent while the background music fades away.

VICKY

(*a little surprised by the silence*)

Ladies and gentlemen, it was impossible to find this man worldwide until today. The Church persecutes him, the police chases him, the extremists have elected him as their leader... We managed to meet him … talk to him … understand him!

 TONIA

And he agreed to do something he would never
have done: come here exposing himself to the
cameras … but above all performing a miracle in
real time, here, for us … thus finally
demonstrating to everyone his indisputable
divine origins!

Shy protests with a more timid applause begin
to arise from the audience.

 A SPECTATOR

Liars! It's all a setup! You can't force anyone
 to make miracles!

 ANOTHER SPECTATOR

You are impostors! The real son of God would
 never do such a thing!

 A SPECTATOR

 This stuff isn't done for TV show!

 A SPECTATOR

 (continued, quoting The Writings)

 "Let not your right hand know what your left
 hand is doing"!

Again confused murmuring: part of the audience
is displeased and a thunderous chattering
arises.

 TONIA

 Silence, please, silence! Watch and believe!
 Doubts and questions only after the miracle!

 A SPECTATOR

 Yep we're so curious to see this Goddamn
 miracle!

Part of the audience starts laughing, but the
laughter is immediately interrupted by VICKY
who makes gestures to the director to pump up
the music volume.

The lights dim and a screen hanging in mid-air behind the armchair and behind VICKY and TONIA is lighting up and the well-known web images of Stigmatler that have been seen worldwide begin to appear: his walking on the water; he speaks with the earthquake victims; together with the Disciples he's working miracles for immigrants. Applause. The movie ends. Lights again. Drumroll.

 VICKY

Ladies and gentlemen, this is the most exciting moment of our lives! We have just introduced you to the Guest Star you are all anxiously awaiting! This guy is nowadays more famous than Jesus Christ!

 VICKY AND TONIA

 (aloud together)

 Stigmatler!!!

Growing drumbeat suddenly stops while whistles and applause continue. A light from above illuminates the armchair. STIGMATLER although hesitant appearing at the bottom of the stage and comes forward. Dead silence descends on the audience: everyone is amazed to see that man totally identical to Adolf Hitler actually proclaiming himself the Messiah. STIGMATLER advances limping and sits on the armchair accompanied by the TWO GIRLS. He seems clearly uncomfortable. Enthusiastic but also in great tension VICKY and TONIA sit on two high white settles on either side of the armchair with STIGMATLER on.

SCENE 57. INTERIOR/NIGHT. HIGH MOUNTAINS LANDSCAPE. DISCIPLES' BUNKER.

ALL THE DISCIPLES together with GRETL are watching through the unstable connection of their I-Pad the live broadcast with Stigmatler, Vicky and Tonia. They are incredulous.

> GOERING
> It is not possible. I can't believe it.
>
>
> PRIEBKE
> Sure that is all made with A.I. or C.G.I. It
> can't be real.
>
>
> GRETL
> It's terrible. How could this happen …
>
>
> GOEBBELS
> Maybe they drugged him... he's under the
> influence of drugs. They certainly forced
> him...

GRETL

Sssht … Shut up! Wait. Let's see what's going on.

SCENE 58. INTERIOR NIGHT. MEGADIRECT TELEVISION STUDIOS.

STIGMATLER sits completely mute in front of thousands of spectators (and billions at home). VICKY and TONIA betray a certain embarrassment: they look each other and realize that STIGMATLER is heavily violating the show times with these silence. The TWO GIRLS try to save the situation.

 VICKY

 (*trying to be ironic*)

Stigmatler ... Or can I call you Stigma?

Nobody laughs.

 VICKY

 (*continuing*)

Having established that we think you are the Son of God returned to Earth to teach humans to see Good in an Evil appearance ...

 TONIA

 Enough, Vicky, enough. Stop kidding. What
 miracle do you want to make for us this
 evening, Stigmatler?

 STIGMATLER

 (*after a long pause*)

 I won't do anything. No one can force God's
 hand.

VICKY and TONIA terrified look at each other.

 VICKY

 Darn it. You promised us you would show us the
 great mystery... the House of Your Father.

 TONIA

 (*Meanwhile Tonia notices STIGMATLER's wrists
 they're no longer bleeding*)

 Yes, we want to know if there is something
 after life!

STIGMATLER

(*chilling tone*)

I repeat, I cannot perform any miracles here.

VICKY

(*to the audience*)

He's a bit shy... He's not used to TV shows.

TONIA

Come on, Stigmatler, show us what you can do. Show us the beyond, if there's one ... Tear away the veils of what awaits us after death. For the first time the world will be able to know the truth!

VICKY

(*to STIGMATLER now in an imperious tone*)

You promised!

Choruses of disapproval begin to rise from the studio audience.

 STIGMATLER

 (*apparently calm*)

 Alright then. Your will be done, my beautiful
 liars.

 (*He grins sardonically*)

SCENE 59. INTERIOR/NIGHT. HIGH MOUNTAINS LANDSCAPE. DISCIPLES' BUNKER

DISCIPLES are astonished. GRETL is the most astonished. They feel betrayed by their Master.

 HESS
 (*looking at the I-Pad screen*)
My Gosh, look! Look what's happening now!

A sudden flash invades the screen and the live broadcast skips. The screen becomes completely black. Then some strange interference causes white noise so you can no longer see anything. THE DISCIPLES look at each other and do not understand what is happening.

SCENE 60. INTERIOR/NIGHT. TV STUDIOS.

In the studio we hear an inhuman noise coming from the floor. Cameras suddenly stop working: the lenses break up. The audience doesn't react at first but then many begin to run in terror and look for the exit. A roar tears through the floor of the stage opening a large hole from which sulfur and smoke come out. VICKY and TONIA scream. In the middle of that mess they notice that the armchair with STIGMATLER is sucked inside by the ground and now at STIGMATLER's place there is ILVASTOR (the former beautiful SMUGGLER) looking at them sarcastically. He is now definitively looking like a demon. He stares at VICKY and TONIA.

<div style="text-align: center;">

ILVASTOR

(*sarcasm flashes in his eyes*)

</div>

Truly I say to you, this day you two will be in everlasting Hell with me.

VICKY and TONIA try to escape but they can't get off their white settles caused their bottoms are glued and the two settles are dragging into Hell together with ILVASTOR who pulls them by their clothes tearing them off.

The TWO GIRLS scream like hell and their once splendid bodies are becoming black as soot while their faces have become monstrous and nasty. The audience leaves the theater in fear but many are dying on the spot crushed by those who are trying to save themselves. The screams and confusion create unspeakable pandemonium.

SCENE 61. INTERIOR/DAY. HELL

VICKY TONIA and ILVASTOR fall into a bedlam of the damned in the midst of hellish fire. We glimpse A TORTURE DEMON who is humiliating THREE DAMNED. TWO are THE DI-SYRIOUS TWINS - two filmmakers from Piedmont that won many awards at movie festivals here condemned to be gypsies and dig through infernal trash cans continually eating what they find including shit. Another DAMNED is the former Turin filmmaker LEWIS BLANKON who was missing a hand in life. BLANKON is forced by the TORTURE DEMON to continually cut off his hand, watch it regrow and then cut it off again endlessly. VICKY and TONIA now 2 unwatchable monsters observe this spectacle before they too are definitively absorbed into the general hellish mess where they will be tortured forever by ILVASTOR, the devil of lust. VICKY has transformed into a gigantic snail worthy of Bosch painting while TONIA has become a monster in the shape of a perpetually incandescent vagina. There's also STEPH GAVI among the damned: he was a powerful movie manager in life. Now his condemned to drink big Molotov bottles eternally.

SCENE 62 . EXTERIOR/INTERIOR. DAY. HIGH MOUNTAIN LANDSCAPER AND BUNKER DISCIPLES.

The sun has set on the mountain. All gathered in the bunker together with GRETL, THE DISCIPLES are sleeping soundly and I-PAD is quit on the ground. At a certain point the tunnel is illuminated by a great light and sound of footsteps is heard. The 12 APOSTLES begin to wake up lazily.

 HESS

 (*stretching*)

 What a night…

 HIMMLER

 There's someone out there…

 GRETL

(*looking at the entrance, shouting full of joy*)

 Master!

STIGMATLER appears bruised on the doorway. Everyone wakes up and gradually goes towards him to welcome him. The first one to approach him is GRETL.

GRETL

(*taking care of him while STIGMATLER collapses tiredly on the ground*)

You are back, Master! But then, last night…

HIMMLER

Yep, it's amazing! We saw you on TV show…

STIGMATLER

(*tired on the ground*)

My dear friends, may you be blessed forever.

 GOERING

Master, please give us an explanation... Is it
 really you?

 STIGMATLER

 I do.

(*STIGMATLER shows his bleeding wrists*)

What you saw last night was a deception of the
Evil One who persecuted me by permission of the
Lord. But now he has been cast back into the
depths of the abyss and those ones that served
 him have followed.

 HESS

Master, where have you been all this time?

 GRETL

In prison. Can't you see that they tortured
 him?

(*Gretl wipes the blood from his face with her
 scarf*)

STIGMATLER

My mission here on Earth is about to end. Once again men did not believe me and the confusion created by Satan last night did damage. It's time for me to leave again and then rise again.

SCHRECK

Master, does this mean you're leaving us?

STIGMATLER

Truly I tell you: I am with you until the end of times. Now you will have to follow me for the final sacrifice.

GRETL

Master... What are you speaking about?

Everyone looks at each other with questioning expressions.

SCENE 63. EXTERIOR/DAY. ABANDONED LAGER AND DISMISSED CREMATORIUM.

We are in a place similar to Mauthausen. There is no one around and STIGMATLER and the 12 DISCIPLES accompanied by GRETL head towards the now abandoned concentration camp - but open from time to time to visitors. STIGMATLER uses the his stigmata to deactivate alarms and open the gates. It's 5.30 AM. STIGMATLER enters the former lager followed by the DISCIPLES. They head towards the area of the crematoria. GRETL has tears in her eyes and APOSTLES too. STIGMATLER opens one of the ovens again thanks to the miraculous effects of his stigmata, then reactivates it: the oven begins to become hot.

STIGMATLER

(*to all*)

Now I have to return to the Father's House. You will stay here and wait for me. In three days I will resurrect and show myself to you and to the world. You are allowed to film my death and spread the news. Remember that even if you no longer have me among you I will always be within you in heart, body and spirit.

GRETL

(*in tears*)

Master, why? Why do you have to leave us? What will we do after you have gone?

STIGMATLER

Get away from me, Satan!

GOEBBELS

Master, please don't be so hard with her. She loved you so much. Like all of us after all.

STIGMATLER

My dears … you'll be blessed every time they persecute you because of me! Go back to the bunker and wait for me on the mountains.

HIMMLER

Master … please don't go.

STIGMATLER turns around while the reactivated oven is now very hot. STIGMATLER enters and closes the door. GRETL desperately throws herself on the closed door and tries to reopen it but the other ones hold her back. ONE OF THE APOSTLES is filming the scene with the I-PAD camera. STIGMATLER smiles and then an immense light invades the oven followed by a dense and blazing fire. STIGMATLER has disappeared.

SCENE 64. EXTERIOR/INTERIOR. DAY. HIGH MOUNTAIN LANDSCAPE AND DISCIPLES BUNKER.

Back at the bunker the DISCIPLES still heartbroken and unhappy await STIGMATLER's return from the dead. A calendar signals the passing of the 3 days while the 12 pray often guided by GRETL. At the dawn of the third day, outside the bunker a great light appears coming from the sky. THE DISCIPLES with GRETL become anxious. In the light there is no STIGMATLER but A WOMAN DRESSED WITH THE SUN - her a beauty is not of this earth. THE DISCIPLES look at her spellbound and one of them tries to film the scene with the I-PAD. Joyful expressions are on their faces. The BEAUTIFUL WOMAN DRESSED OF SUN smiles at them and gives them blessings with gestures. A light fueled by a celestial fire invades the whole landscape.

SCENE 65. EXTERIOR/DAY. HIGH MOUNTAIN SCENERY AND NEARBY THE DISCIPLES FORMER BUNKER.

A FAMILY on holiday in the mountains: DAD, MUM, TWO CHILDREN both about 10 years old, a MALE and a FEMALE. They are sitting at a table in a picnic area not far from the resurrection is happening. THE TWO CHILDREN are both dressed as STIGMATLER with carnival costumes (even the little girl). The DAD is reading the newspaper. The titles speak of the infernal chaos happened in the TV broadcast of the dead Vicky and Tonia and of the definitive disappearance of (fake) STIGMATLER.

 DAD

(*to his wife, commenting on the newspaper*)
What a horrible mess. I still can't believe it.

 MUM

The worst thing is that someone released that disgusting video where he melts himself in a fake crematorium declaring that he will resurrect …

 DAD

 They really don't know what to do to try to
 become famous.

Meanwhile the TWO CHILDREN play with each other
and get far a little. After a few moments the
MALE CHILD dressed as STIGMATLER returns to his
parents screaming.

 CHILD

 Daddy! Mommy! Come and see, come now!

 MUM
 (*annoyed*)
 Leave us in peace.

 CHILD
 Come and see!

DAD and MUM get up and they follow the CHILD who leads them to a corner of the lawn from which they can see the big light. The whole family witnesses the spectacle of this BEAUTIFUL WOMAN DRESSED WITH THE SUN casting blessings from heaven. They notice sometimes that the woman's face is changing: now the face of HITLER appears; now that of CHRIST; in few words it's STIGMATLER. The whole family kneels prostrate.

 DAD
 (commenting on the scene; moved)

 Holy Gods ... Then that man was truly the son of
 God.

END

Credits

www.ingramcontent.com/pod-product-compliance
Lightning Source LLC
Chambersburg PA
CBHW071446220526
45472CB00003B/684